TRUE TALES
of the
Texas Frontier

EIGHT CENTURIES OF
ADVENTURE AND SURPRISE

C. Herndon Williams

Charleston London

THE
History
PRESS

Published by The History Press
Charleston, SC 29403
www.historypress.net

Cover images: view of the Rio Grande River, one of the frontiers of Texas. *Courtesy of David Fulmer*; illustration on how to cross a river with a horse from the book *The Prairie Traveler*, written by Randolph Marcy in 1859.

First published 2013

Manufactured in the United States

ISBN 978.1.62619.029.0

Library of Congress CIP data applied for.

Notice: The information in this book is true and complete to the best of our knowledge. It is offered without guarantee on the part of the author or The History Press. The author and The History Press disclaim all liability in connection with the use of this book.

Dedicated to Linda Brinkley and Miss Elly Bleu.

Contents

Contents

CONTENTS

INTRODUCTION

The eight-hundred-year history of the Texas frontier has many stories; this book contains fifty-eight. The historic period of the Texas frontier starts with the arrival of the Spanish explorers in 1519 and continues through the 1880s, when the frontier closed. The frontier closed when all the free range land was claimed and fenced off with barbed wire. This time also coincided with the widespread arrival of the railroads across Texas and the growth of towns and cities.

But the Texas frontier had a long prehistory before 1519. Humans (*Homo sapiens*) arrived in Texas at least fifteen thousand years ago and maybe earlier, all during the last ice age. This first arrival story is still an area of active research and debate among archaeologists. The first inhabitants will be referred to here as Indians, although "Native Americans" is also sometimes used. However, all residents of Texas migrated here from somewhere else, some sooner than others. This book contains true stories from this prehistoric period of the Texas frontier, back to forty-two thousand years ago. Since there are no written records, the earliest stories of the Texas frontier rely on the results of archaeology, astronomy, geology, chemistry and other sciences.

This book is divided into five parts based on the time phases in Texas history: the prehistoric period through 1519; the Spanish colonial period through 1811; the period of Mexican Texas, colonization by Anglo-Europeans and the Texas Revolution, 1811–36; the Republic of Texas, 1836–45; and the state of Texas from 1845 to the end of the frontier in the 1880s.

INTRODUCTION

The stories were selected to reveal some aspect of life on the Texas frontier. The stories are all true and are intended to be provocative, fascinating and engage you in the life and personalities that defined Texas as a frontier. This frontier feeling is still alive in Texas.

Part I

Prehistoric Texas Through 1519

What the Indians Saw in the Texas Sky in AD 1054

On July 5, 1054, ancient people gazed nervously at a bright star in the night sky that was not there the night before. The new star was four times as bright as Venus and appeared very close to the tip of the crescent moon on that night. A Chinese astronomer of the Sung Dynasty called it a "guest star" and wrote that it was "visible by day like Venus; pointed rays shot out from it on all sides…it was visible by day for 23 days." It could be seen in the night sky for 653 days. The guest star was reported in China, Japan and the Near East and should have been visible in west Texas and the American West. It was not noted in Europe or in South America. The prehistoric people of the time would have been very familiar with the stars in the night sky. Most would have wondered what the appearance of this bright new star portended.

The guest star was a supernova, a stellar explosion often caused by the gravitational collapse of a massive star. Much of the mass of the star is converted into radiation from gamma rays through visible light. A supernova can emit as much energy in its short lifetime as our sun will produce in its entire 100-billion-year life. A supernova also creates a shock wave that contains all the chemical elements heavier than lithium (e.g., carbon, nitrogen, oxygen and iron). These elements then condense into planets like Earth.

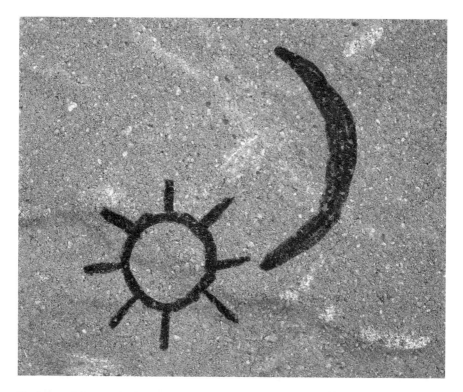

Depiction of how an Indian's rock art image of the supernova of 1054 might appear: as a very bright star at the tip of the crescent moon. *Artwork by author.*

Astronomers have the written records of supernovas going back to AD 185 and can count at least ten that occurred through 1885 originating from stars in our Milky Way Galaxy. In that year, astronomers with telescopes found the first supernova in the distant Andromeda Galaxy. Now astronomers can identify the blasted remnants of a supernova explosion. For example, the supernova of 1054 formed the Crab Nebula.

How would preliterate people have recorded their sightings of a supernova? They would have been very familiar with the cycles of the sun, such as the equinoxes and solstices. Ancient people also studied the more complicated movements of the moon over months and years. The Pawnee had a star chart painted on a deerskin. They would probably also have known about the "wandering" stars, now known to be the planets Venus, Mars, Jupiter and Saturn, which move across the background of the fixed stars in the Milky Way. But imagine their surprise when overnight they beheld a huge, bright new star near the tip of the crescent moon.

Several astronomers have recently looked for representations of the 1054 supernova in the rock art of that time. What they looked for was a pictograph of a bright star associated with a crescent moon. They have found twenty-one candidate rock art sites spread over Texas, New Mexico, Arizona, Nevada, Utah and California. Rock art is very difficult to date, but the sites seem to have the right antiquity. The sites include Chaco Canyon in New Mexico and Painted Rock in Texas.

Besides memorializing the supernova event in rock art, how would the Indians have interpreted the sign? The Indians attached great prophetic significance to the unusual astronomical signs that they were familiar with, like eclipses, comets and meteors. For example, comets and meteors were considered to be bad omens, portending future disasters. There was a meteor shower seen in America on November 13, 1833, that produced many depictions in native art as "the night that the stars fell." We now know that this was one of the periodic appearances of the Leonid meteor shower. But the Indians would have had no experience with a bright new star, perhaps leaving it to a shaman to divine.

Scientists have even found evidence of the supernova of 1054 in Antarctic ice cores. The gamma ray burst from the supernova impacted the earth's atmosphere, producing a spike of nitrogen oxide. In fact, the ice cores indicated another supernova event in about AD 1080 that may only have been visible in the Southern Hemisphere. To date, no rock art representations of supernovas have been reported in South America.

THE GULF BEACH WAS DISTANT TEN THOUSAND YEARS AGO

Ten thousand years ago, the Gulf of Mexico shore was about forty miles farther out, and it was approaching its present location but at geological speed. The last glacial maximum (or ice age) peak endured for about eight thousand years, from twenty-seven thousand to nineteen thousand years ago. The ice locked up in the glaciers produced a drop in the worldwide sea levels of about four hundred feet. So the shoreline then was about where the Gulf is now four hundred feet deep. Archaeologists have found remnants of these underwater prehistoric shorelines. Global warming then caused a melting of the glaciers and a geologically rapid increase in sea level beginning about

nineteen thousand years ago. Due to complex geological causes, the sea level rise was not smooth and continuous but erratic, with some long periods of nearly stable sea level. This turned out to have significant implications for the humans living along the Gulf at the time.

There is ample archaeological evidence for people living in Texas eleven thousand years ago, the Clovis point people. The evidence includes the wide distribution of Clovis stone spear points and associated animal bones. There are even rare human bones from this age. However, there is mounting evidence suggesting that humans were present in Texas and along the Gulf as far back as fifteen thousand years ago. The evidence for earlier human presence is scant: more rudimentary stone and bone tools and butcher marks on mammoth and other fossil bones. To date, no human bones from earlier times have been found.

In the Coastal Bend region of the lower Gulf, around Corpus Christi, archaeologists have found human campsites on the margins of rivers, bays and the coastline. About 10,000 years ago, none of the current bays existed, although the Nueces, Aransas and Guadalupe Rivers did. The Aransas and Nueces Rivers did not flow directly into the Gulf, some forty miles distant, but rather joined and flowed south toward the Rio Grande. Rising sea levels had begun to flood the river valleys and form the precursors of the current bays. The erratic rise in sea levels caused periods of relatively stable sea levels, lasting from 1,000 to 2,000 years. These periods of stable sea levels also correlate with periods of human occupation along the Gulf. Periods of stable sea level occurred from 8,200 to 6,800 years ago, from 6,000 to 4,000 years ago and from 3,000 years ago (1000 BC) to the present.

The human occupation during these periods of stable sea levels can be understood in terms of the formation of the coastal estuaries that we see today, large areas of shoreline shallows with sea grass flats and salt marshes. These conditions promote the growth of the abundant sea life that would support human habitation. This would include an ecosystem of fish, shellfish and aquatic birds and plants. However, rapidly rising sea levels would inundate these areas with seawater and obliterate this ecosystem, causing the humans to migrate inland. This is the sequence suggested by the archaeologist Robert Ricklis.

Sea levels reached their current depth about three thousand years ago when geological action formed the current system of barrier islands, coastal bays and estuaries along the Gulf. Human occupation along the Gulf has been more continuous since that time. The Indians we call the Karankawa possibly arrived in the Coastal Bend at about AD 800 to 1000. Their nomadic life involved living

in large shoreline camps from the fall through the early spring, then breaking up into smaller groups to move inland for the summer. Their hunter-gatherer life served them well until the coming of the Anglo-Europeans, whose settlements occupied some of the traditional Karankawa camping sites.

MAMMOTHS ROAMED THE TEXAS PLAINS

You could find a mammoth bone or tooth in your backyard. They grazed all over Texas until eight to ten thousand years ago. Mammoth fossils have been found in 123 of 254 Texas counties and all along the Gulf Coast. Most of the mammoth fossils have been discovered in large-scale excavations, such as gravel pits, road building or dredging, but some still turn up in backyards. Archaeologists have carbon-dated a mammoth skeleton found in a gravel pit near Clute, Texas, at thirty-eight thousand years old. Floods have also caused the bones to be exposed in riverbanks or washed into gravel beds. Waco is the site of the concentrated bones of about twenty mammoths that died together in a flood about sixty-eight thousand years ago.

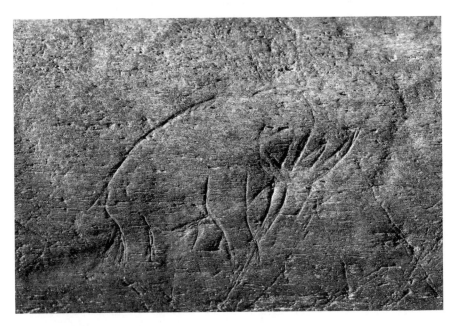

Indian rock art image of a mammoth, thirteen thousand years old. *Wikimedia Commons.*

The mammoth is an extinct species of elephant that is believed to have originated in North Africa about 5 million years ago. From there, they migrated around the globe and are thought to have been in North America by 100,000 years ago. Mammoths became extinct worldwide at the end of the last ice age, around 10,000 years ago, although some survived in remote Arctic sites until 5,000 years ago. The woolly mammoth lived only in frigid climates, but the Columbian mammoth ranged throughout the lower part of North America, even down into Mexico. The mammoth was bigger than the modern African elephant and was distinguished by large inwardly curving tusks. A set of curved tusks for a Columbian mammoth found in central Texas was sixteen feet long, the longest ever found for any elephant. The mastodon was a shorter elephant species, with tusks more like modern elephants, and was found in eastern North America.

The woolly mammoths were a very successful species and are thought to have migrated from Siberia to North America across the Bering land bridge during a much earlier ice age. They moved south when the climate in North America was cooler and wetter than at present. Texas then would have been a mixture of grassland and forests that well suited their herbaceous diet.

Humans encountered mammoths in Texas, and a predator-prey relationship existed between them at least as early as 11,500 years ago during the Clovis period. The use of Clovis-age stone tools at mammoth kill sites has been well documented in Texas, as well as across North America. In fact, hunting by humans is considered to be one of the contributing factors to mammoth extinction, along with climate change.

In a recent twist in research perspective, a group of archaeologists has been looking at mammoth bone fossils for evidence of human use before Clovis time (i.e., before 11,500 years ago). Since Clovis stone tools are the oldest well-documented tools, there are fewer stone artifacts to be found with the older mammoth fossils. But how would the humans have killed the mammoths without stone-tipped spears? The humans may have come upon dead mammoths opportunistically (i.e., killed by natural events), or they might have caused a herd to stampede over a cliff by the use of fire. However, the archaeologists did find evidence in the fossilized mammoth bones of human use: cut marks to indicate butchering and the fracturing of bones to access the marrow and for use in making bone tools (e.g., bone-tipped spears). The dating is difficult, but it looks like this was done in the period of at least 1,000 to 2,000 years before Clovis. This and other evidence indicates that humans may have been in America and Texas as

early as 18,000 ago. Meanwhile, mammoth teeth are about as big as your two fists put together and have ten to twelve ridges or folds across the tooth. So keep an eye out while gardening.

DISEASE AND ILLNESS IN THE AMERICAS BEFORE COLUMBUS

The cause of population decline among the indigenous inhabitants of the Americas after the coming of Christopher Columbus has long been attributed to the advent of the European epidemic diseases (smallpox, influenza, measles, typhus, cholera, mumps, pneumonia, whooping cough and tuberculosis) that were chronic in Europe and Asia. The combined impact of all these diseases was to cause the deaths of 80 to 90 percent of the indigenous American population within about 150 years. Estimates of the pre-Columbian population in the Americas are uncertain, but a number of 50 million is possible. By 1650, only about 8 million were left.

One source of these diseases among Europeans was transmission from domestic animals such as cows, sheep, goats and pigs. For example, the domestic cow was the source of smallpox. Europeans had several thousand years of contact with these animals, and the sensitive population had already died. The Europeans who survived had some resistance to the disease, and this resistance increased over the generations by natural selection. Since the native population in the Americas had very few domestic animals, they were very susceptible to these European diseases.

Archaeologists and other medical scientists have tried to determine the diseases native to North and South America before Christopher Columbus. One of these was a particularly virulent form of syphilis. Syphilis was native to the Americas, so Europeans had no resistance to it. Syphilis became rampant in the Old World after 1492, and the affected Europeans often died of it within a few months. But syphilis seems to be the only major disease brought back to Europe and Asia from the Americas.

The list of other diseases and chronic illnesses found to be present in the New World is very long: malaria, tuberculosis, anemia, epilepsy, typhus, scurvy, anthrax, hemorrhagic fever (*cocaliztli* in Aztec), intestinal parasites, pneumonia, meningitis, dysentery, gall bladder disease, Chagas disease, yellow fever ("black vomit"), head lice and dental caries. Interestingly, pet

howler monkeys were the source of malaria in ancient Peru. To this might be added ailments of a psychosomatic origin, such as susto or magical fright. All this has been determined from study of Spanish records, some skeletons, mummified remains, coprolites (fossilized dung) and effigies (pottery and drawings). Acute diseases and skin lesions would not generally be detected by these methods. The Spanish conquistadors destroyed most native records as being "the work of the devil."

The Aztec had a very extensive apothecary of 204 medicinal plants and herbs, as well as a sophistication in medicine that surprised the Spanish. The art of surgery in South America was highly developed, including limb amputation and trepanning, or cutting out large circles of bone in the living skull. But medical skills varied highly across different native populations and were ineffective against the European diseases.

The hunter-gatherer groups were actually healthier than the more advanced agricultural societies. They avoided most of the intestinal parasites that came with crowded living and poor community hygiene. And their diet, while more meager, was more varied. Agriculture and "civilization" promoted a more sedentary lifestyle. Hunter-gatherer groups also tended to be more widely dispersed. Dental caries increased with the introduction of corn and other grains into the diet. While agriculture brought many benefits to those who evolved into our modern society, better health was not one of them.

ALL THE WORLD'S CAMELS CAME FROM TEXAS

Well, okay, maybe not from Texas specifically, but all camels did come from North America, and Texas did have a camel population. There is a camel fossil at the sixty-eight-thousand-year-old mammoth fossil site outside Waco. Actually, a number of the animals in the world were originally native to North America. The camel is one, and the horse is another. We know that Alaska and Asia were connected by a land bridge over the Bering Strait during earlier ice ages. This land bridge is called Beringia, and it is hypothesized that humans reached America from Asia over this land bridge during the last ice age. However, there was two-way traffic on these land bridges. Were the camels walking backward so as not to attract attention?

Camels crossed a land bridge into Asia, but much earlier than the last ice age. There have been numerous ice ages, as they come in cycles. Geologists

have found that a typical cycle would consist of a long cold period of seventy to ninety thousand years, followed by a rapid warming over five to ten thousand years. This is followed by a warm period, called an interglacial, which lasts for ten to thirty thousand years. We have been in our interglacial period for about thirteen thousand years now. This also means that much of the evolution of *Homo sapiens* occurred during the last ice age. An ice age does not cover the earth with ice. The glaciers just grow and advance more to the south (i.e., a little way out of Canada). But the water bound up in the glaciers caused the sea level to fall by about four hundred feet in the last ice age, exposing the Bering land bridge.

The American camel was running around in North America with other ice age beasts like the mammoth, mastodon, saber-toothed cat, giant armadillo, giant ground sloth and horse. Almost all of them went extinct in America at the end of the last ice age, about twelve thousand years ago. The first people in America may have had a hand in their extinction. Recently discovered in Colorado, some Clovis stone tools still had the residue of camel and horse butchering.

The American camel was slightly taller than modern camels, standing about seven feet at the shoulder, and probably had no humps. The humps evolved later. The American camel probably looked a lot like a big llama—and for good reason. When the Isthmus of Panama rose about 3 million years ago to connect North and South America, the American camel migrated south and evolved into the llama group (llama, alpaca, guanaco and vicuna). Many other animals passed in both directions across the Isthmus.

The camel had already crossed into Asia over the Bering land bridge much earlier and began its migration around the world. New World and Old World camels diverged from each other around 11 million years ago. So while the American camel went extinct, camels flourished in other parts of the world. The ancient people of Somalia were among the first to domesticate camels more than four thousand years ago.

Camels came back to Texas briefly and experimentally in the 1860s. Before the Civil War, Jefferson Davis imported about one hundred camels and ten Arabic handlers to try them as beasts of burden for the U.S. Army in the desert southwest. The camels performed admirably but lost the political battle. Their success was tainted by Davis's later service as president of the Confederacy. Also, horses and oxen were spooked by camels and became uncontrollable in their presence. So the camels were left to run wild and became extinct in America a second time. Done in by the horse and oxen lobby.

CLUES TO THE EARLIEST HUMANS IN TEXAS

Archaeology has typically relied on skeletal remains and stone tools as early evidence for the presence of *Homo sapiens* and other hominids. Skeletal remains in Africa date human presence there back to 100,000 years ago and hominid ancestors back 4 million years ago. Carbon-14 and other dating techniques have established these ages, although neither stone tools nor ancient bones can usually be dated directly because they contain no residual carbon. The date of the first humans in the Americas (i.e., the first Americans) is much more recent, in the range of 14,000 to 30,000 years ago, but it is more difficult to establish. The scarce skeletal remains found so far in the Americas date back to only about 11,000 years ago. The oldest stone tools of definitive human manufacture are those that are classified as pre-Clovis and date to about 15,000 years ago.

At a number of archaeological sites in the Americas and in Texas, stone tools have been found at levels deeper than Clovis, which could make them older. But stone tools that might be older than Clovis suffer from the limitation that they are cruder (i.e., they show lower levels of human workmanship and could have been formed by natural processes). In fact, early man may have used naturally formed rocks with sharp edges as killing or butchering tools. In some pre-Clovis sites, bones of mammoths and other megafauna have been found with incised cut marks that look like they were the result of butchering (i.e., cutting meat off the bone). Sometimes collagen can be extracted from these bones for carbon dating. Charcoal that came from a hearth or campfire can certainly be carbon dated, but it is difficult to distinguish it from the residue of a naturally occurring brush fire. Cut marks on big bones and hearth charcoal, then, are some of the surrogate indicators that archaeologists use to infer human presence, but these indicators have to be supported by other evidence before human presence can be unequivocally confirmed.

With human skeletons so scarce, archaeologists will look at anything related to human presence. Human coprolites (fossilized dung) have been found in a few caves and carbon-dated to as much as a thousand years earlier than the 12,000-year age of Clovis. Coprolites from a cave in Oregon even yielded human DNA. The mitochondrial DNA of the coprolite yielded a pattern that matched that of Native Americans. The distribution of different patterns in the mitochondrial DNA of Native American groups has supported the hypothesis of at least two migrations into North America

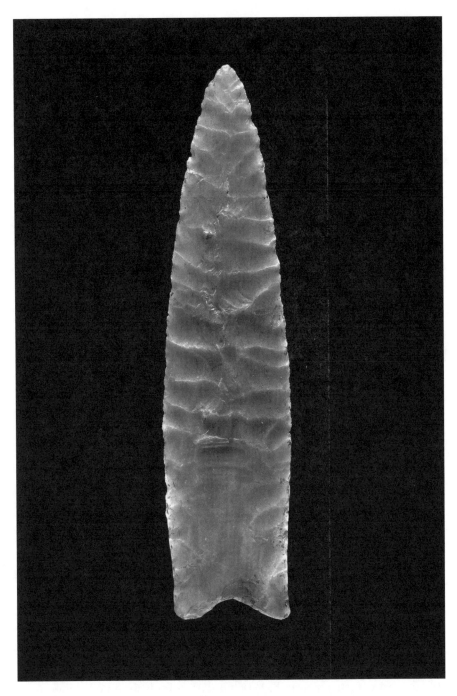

Clovis spear point, 10,000 BC. *From archeology.about.com.*

from Siberia: one along the Pacific Coast and one through the interior of Canada. Other evidence also suggests earlier immigration from Europe.

One recent use of an innovative surrogate provided significant evidence regarding the history of megafaunal decline and extinction in America. These megafauna—including mammoth, mastodon, ground sloth and bison—became extinct about ten thousand years ago in the Americas. It has been proposed that hunting by the first Americans contributed to or caused their demise. Researchers at the University of Wisconsin–Madison used a fungus (*Sporomeilla*) that thrives only in the dung of large herbivores as a surrogate for the megafauna. They analyzed for this fungus in the ancient sediments of a lake in Indiana and found that the decline of the megafauna started about fifteen thousand years ago and was essentially complete by the time the Clovis people were on the scene. So, Clovis hunting could not be a significant factor in megafauna extinction. Other options include pre-Clovis hunting and climate change (i.e., global warming).

Archaeologists have also used the distribution of different strains of bacteria, viruses, soil fungi and even lice in current human populations to help track the migration of ancient peoples. They have gone well beyond the traditional study of stone tools.

150 STONE POINT TYPES FOUND IN TEXAS OVER TWELVE THOUSAND YEARS

There are more than 150 stone point types found in Texas ("types" means that they look different). However, the types compiled by archaeologists are usually intended more as a cultural description, but they also include physical specifications. Stone points are what people usually call "arrowheads," although they were actually spear or dart points. There are an additional seventeen types of arrowheads, which are much smaller than dart points. In Texas, the number of found dart points is huge, probably close to 1 million, maybe more.

The different appearances of dart points have been noted by archaeologists and amateur collectors for more than one hundred years. After much research and discussion, archaeologists have derived more than 150 types, but this is still an area of active research. When a dart point is found on the ground, there is little information other than its location. But archaeologists have been

studying the context of stone dart points to determine their chronology, their geographical distribution and the environmental conditions of their use.

The earliest named stone point in Texas was the Clovis point, first identified near Clovis, New Mexico, in 1929. The shape of the Clovis point is very distinctive, and for a while, it was thought to represent the first people to live in Texas, about 12,000 years ago (BP, before present). Recent archaeological finds in central Texas have shown that there were people living and making stone tools 15,500 years ago. These older points were cruder than Clovis and have not yet received a type name. Other evidence suggests an even earlier occupation, perhaps 20,000 years ago. Clovis tools were made for only about 300 years but have been found very widely across North America and even in Alaska, Mexico and Central America. Other point types followed Clovis, given names like Hoxie, Andice, Bulverde and Perdiz. The time span of the 150 types ranges from 12,000 to about 1,000 years BP, right up to the historic period when stone was replaced by glass and metal.

Michael Collins, Elton Pruitt and other archaeologists have been able to determine the chronology of the different point types, and Collins has looked at the climatic conditions (wet or dry) and the presence of bison in Texas. There is no obvious progression in the development of point types (i.e., from crude to refined). Also, there is no association of point types with a particular band of Indians. So, the rationale for the development and distribution of point types is not apparent. Some point types have been found all over Texas and even in neighboring states, but some have been found in only a limited geographical area of Texas. There is some correlation of the form of the stone point for bison hunting (e.g., a long, thin, broad two-edged spear point). The point was hafted, and the spear was either thrown or launched from an atlatl.

Bison were generally only present in Texas during wet periods and were absent for up to 2,000 years of dry climate. Bison and mammoths were plentiful in Texas for about 3,000 years at the end of the last ice age, from 13,000 to 10,000 years BP. During that time of bison abundance, the finely made Clovis point evolved into the Folsom and Plainview types. It is not clear where the Clovis point came from or why it went away. The closest apparent antecedent to the Clovis point is the Solutrian point from Europe, and there is nothing from Asia. This had led some archaeologists to speculate that the first people to enter America came from Europe. An alternative hypothesis is that the Clovis point was invented here.

At times, four or five different types were being used concurrently in the same regions of Texas. How the different type technologies were originated

and disseminated is not known. The presence of bison is inferred from buried bones. The dryness or wetness of the climate is inferred from two independent proxies for moisture: tree and grass pollen in bog sediments and the relative populations of shrews. The least shrew requires moist habitats, and the desert shrew prefers arid habitats. The climate conditions are delineated only as "wet" or "dry" or as a transition between these two states. Archaeologists now know much of the what, when, where and how of Texas stone points, but the whys are elusive.

CORN CULTURE IN THE AMERICAS PREDATES THE PYRAMIDS

The cultivation of maize, or corn, originated in the Americas and is about as old as agriculture in the Old World. The date of domestication of maize is lost in the fog of prehistory but is thought to have originated in Mexico between seven and twelve thousand years ago, the same antiquity as agriculture in Mesopotamia and older than the pyramids of Egypt. Although maize definitely started in Mexico, its domestication was highly improbable, and its migration through the Americas was erratic and slow. Columbus and other explorers found corn as the staple diet of Indians in both North and South America. Spanish explorers into Texas in the 1500s found maize being grown only by the Caddo in east Texas.

The origin of maize in Mexico was the subject of extensive modern research and often acrimonious debate since the 1960s. Part of the mystery is that no wild maize ancestor has ever been found. But a team of archaeologists looking specifically for evidence of maize agriculture dug in caves near Oaxaca, Mexico. They eventually found twenty-four thousand maize cobs, but they were the size of a cigarette butt. After much study, they concluded that maize is a genetic modification of a wild mountain grass named teosinte, which looks nothing like maize. Incredibly, maize was hybridized or genetically modified by the indigenous people by careful plant selection. Maize can not propagate itself; the kernels are wrapped inside a husk too thick for that. The kernels have to be separated and manually planted. The observant Indians selected the plants that they wanted to propagate, and it could have happened in as few as ten seasons. Why they selected teosinte is still a mystery. As a modern geneticist said, "To get maize from teosinte is so

crazy that you could not get a grant to do it today. However, anybody who did it would get a Nobel Prize."

But once started, the Olmec, Maya, Toltec and Aztec elevated maize to the status of a diety. The Indians developed a system of agriculture in which the maize was planted in mounds with beans and squash. The beans climb the maize stalk like it was a lattice, and the roots of the beans fix nitrogen in the soil as a nutrient to the maize plant. The squash acts as a ground cover conserving water and deterring weeds. This system of agriculture is called a milpa, or the "Three Sisters."

Maize was further developed and hybridized in central Mexico, resulting in much larger ears by about 1800 BC. At about that time, maize culture and the milpa began to migrate slowly both north and south from Mexico, reaching southeastern North America in the first millennium AD. The prehistoric Caddo culture made the transition from hunter-gatherers to agricultural village life in about AD 1000, based on corn culture. The Caddo were a regional offshoot of the large Mississippi Valley moundbuilding culture. They occupied the four-corner area of Arkansas, Louisiana, Oklahoma and Texas. The Caddo lived in farming communities, growing a variety of crops (including tobacco) and skillfully making tools, pottery and baskets. The Caddo also produced salt by evaporation of brine seeps and traded it widely. Archaeological studies show that some Caddo were much wealthier than others and had elaborate ceremonial burials. The Spaniard Hernando de Soto encountered the thriving Caddo in his expedition in the 1540s. The Caddo may have been the most civilized Indians in Texas.

Corn culture and the milpa system continued to migrate northeast, reaching into lower Canada before the arrival of the English Pilgrims in the 1600s. Corn culture changed the prehistoric landscape in America as the Indians slashed and burned forests and grasslands to plant maize. Indians in New England selected varieties to accommodate their shorter growing season. Yet the Indians were able to harvest a bounty of maize and store the dried kernels in sacks and baskets for the winter.

Those Europeans who immigrated to America, including Texas, learned corn culture from the Indians or the Spanish, embracing it as their staple grain until wheat could be grown. But the Texas immigrants encountered many Indian groups, like the Karankawa and the Comanche, that practiced no agriculture and still followed a nomadic hunter-gatherer way of life. Corn culture was exported to Europe and beyond and is now the most-grown grain in the world.

Deep-Sea Fishing Forty-two Thousand Years Ago

Humans have been deep-sea fishing for at least forty-two thousand years, as new evidence shows. This is about the same time that *Homo sapiens*, migrating out of Africa, reached Australia. The sea level was a lot lower then since it was still in the middle of the last ice age, some four hundred feet lower. The continental land mass, called Sunda, contained many high areas that later became islands, like Java, Sumatra and East Timor. But that still left a gap of open sea at least fifty miles wide between Sunda and Australia, which the first settlers had to cross on something like primitive boats or bamboo rafts.

Recent archaeological finds in East Timor have indicated that the people of this area were deep-sea fishing forty-two thousand years ago. The evidence was excavated in a highlands cave in 2005. The materials found included well-preserved faunal bones, ten thousand chert artifacts, shell beads and fishhooks made of bone and shell. Among the abundant fish bones was the surprising discovery that most of these bones were from deep-sea fish like tuna and shark. Also surprising was the finding of bone fishhooks made in a modern J-shape.

The evidence of the tuna bones and the fishhooks indicates that the people had highly developed navigational and planning skills, including the ability to leave from one spot and then return to the same place with their catch. Archaeological remains in Australia show that these skilled navigators were *Homo sapiens*, and genetic studies indicate that the current aboriginal population are directly descendants. The dating of bones and rock art in Australia give a human arrival time of about fifty thousand years ago.

There are no remains of any boats or rafts of this age in Australia because they would have been made of wood or bamboo. However, there is a depiction of a boat in one of the oldest examples of aboriginal rock art: an orange ochre painting of a narrow boat with a high prow and three human figures using paddles, dated to about forty thousand years ago. There is also a petroglyph that could be a long canoe with about twenty figures in it. The next-oldest artistic figures of ships were done much later by the Egyptians about five thousand years ago.

Homo sapiens originated in Africa some 200,000 years ago and began to move out of the continent about 100,000 years ago. But *Homo sapiens* did not arrive in Europe until about 50,000 years ago. Europe had been home

to the Neanderthals (*Homo neanderthalensis*) for several hundred thousand years, but the famous cave paintings in France and Spain were executed about 40,000 years ago and have been attributed to *Homo sapiens*. So the arrival of *Homo sapiens* in Europe and Australia were contemporaneous, as was their artistic expressions on rock and in caves. No boats are shown in the caves in Europe since none would have been required in that migration.

There are no depictions of boats in prehistoric America, but archaeological evidence on the Catalina Islands off the coast of California shows an indigenous seafaring people living there twelve thousand years ago. The archaeological finds do not include evidence of deep-sea fishing, but the stone artifacts implied travel to the distant mainland—therefore by boat. This archaeological evidence supports the hypothesis that the first settlers to the Americas came by boat rather than overland. There is no evidence that deep-sea fishing occurred in the Gulf. If it did, the evidence would be under four hundred feet of water now.

The use of boats by the first immigrants might also help explain the fact that the oldest settlement sites in the Americas stretch all the way down to Monte Verde in Chile and to Tierra del Fuego at the southern tip of South America. But there is an Australian connection! A Brazilian anthropologist has made detailed studies of dozens of skulls found in South America and found that they look most like the heads of people from Australia rather than Asia. For this to be correct, the seafarers from Australia would have had to make an eight-thousand-mile trip from Australia to the coast of South America. Impossible? Three years ago, five African fishermen were blown by a storm across the Atlantic to the coast of South America. Deep-sea fishermen are a hardy lot, and prehistoric humans were more daring than we give them credit for.

Cahokia

Cahokia was America's largest "city" in AD 1000, and it stretched from Wisconsin to Texas. Okay, maybe that is a bit of a stretch. More accurately, the prehistoric moundbuilding or Mississippian culture extended from Wisconsin to the Caddo culture in east Texas and was centered on Cahokia, a site located where St. Louis is today. In fact, St. Louis bulldozed many of the mounds in Cahokia in the 1870s as

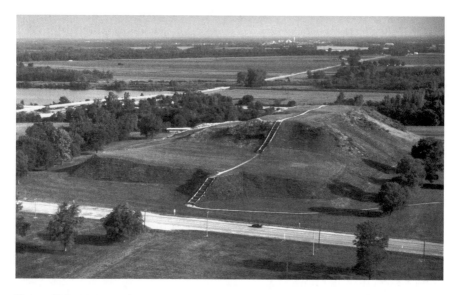

Photo of Monk's Mound, the largest mound at the Cahokia site. *From quofateferunt.com.*

part of its urban sprawl. These were massive ceremonial mounds of earth; Monk's Mound covered fourteen acres and was one hundred feet high, with a fifty-foot-high building on its crest. Cahokia is estimated to have had a regional population of fifty thousand. In AD 1200, the total population of Cahokia was comparable to that of London or Paris. Yet soon after AD 1300, Cahokia was completely abandoned, and there is no record of which Indian group lived there. The Caddo in Texas have persisted into historic times.

Cahokia was never a densely populated city but rather the cultural center of a region of agricultural hamlets and farmsteads. The Mississippian society was not united or cohesive in a political sense. It was a collection of fragmented and combative chiefdoms, each of which lasted no more than a few hundred years. They seemed to be united only in their moundbuilding practices, yet the culture lasted for more than one thousand years. They had no written language, so their history must be pieced together from the stone relics and artifacts found buried in the mounds. They also shared in corn agriculture but still adhered to a hunter-gatherer way of life. The people assembled at the mounds complex at Cahokia for ceremonies that must have lasted for days. In one garbage pit, archaeologists found the remains of nine thousand deer. So Cahokia acted more like a seasonal ritual center.

The Cahokia site was truly impressive, the largest pre-Columbian structure north of the Rio Grande. Monk's Mound was the largest in a group of 120 mounds surrounding the Grand Plaza at Cahokia. Monk's Mound contained almost 1 million cubic yards of earth, hand-carried in at least 6 million baskets. The Grand Plaza covered about fifty acres and was 1,600 feet long by 900 feet wide. Adjacent to Monk's Mound was a 200-foot circle of tall wood posts, a "Woodhenge," laid out in an astronomical pattern, marking solstices and equinoxes.

This is all sounding reminiscent of the stone temples and plazas of ancient Mexico and Mesoamerica. However, recent radiocarbon dating of the earliest stages of the mounds at Cahokia shows that some were laid down five thousand years ago. That would make them older than the first cities of the Olmec in Mexico, which date to three thousand years ago. So who came first? Since corn was developed in Mexico about nine thousand years ago, we know that there was an ancient connection between Mexico and Cahokia.

Evidence for social stratification and for a ceremonial leader was found in a grave mound excavated near Monk's Mound. A man in his forties was buried on a bed of forty thousand seashell disc beads. The shell beads were black-and-white and arranged in the shape of a falcon, with the body of the man lying head to head and arms to wings. The falcon-warrior was a common icon of the Mississippian culture. Archaeologists also found some 250 other skeletons in the same mound, most with signs of a ritual execution, indicating sacrificial victims, including a mass grave of fifty women about twenty-one years old.

Cahokia was built in stages, with the last stage from AD 600 to about 1300, after which it went into steep decline. Cahokia was abandoned by the time the first Europeans arrived in the early 1700s. However, the mounds were still in evidence and mystified the early explorers. Some simply thought that they were natural, but others attributed them to the work of Vikings, Maya, the Lost Tribe of Israel or space aliens. Subsequent work has found evidence for mounds built from Wisconsin to Louisiana along the Mississippi and as far west as Caddo country in east Texas. The monumental mounds of this prehistoric American civilization would rank with the wonders of the ancient world like Stonehenge and the Great Pyramid of Giza.

The Complexity of Native Languages in the Americas

There were more than five hundred languages being spoken in North America when Christopher Columbus landed in 1492. Notwithstanding the stereotype of an Indian speaking pidgin English ("Indian likeum fire water heap much"), native languages were as complex and different as Latin, English and Chinese. This meant that neighboring tribes may not have been able to converse with one another. The situation in South America was even more complex, with perhaps one thousand languages being spoken. Only a very few of these had any system of writing.

The question of why there were so many different languages has not been answered definitively. Linguistic theory certainly allows for the proliferation of languages and dialects when the speakers are physically separated, as was the case with widely dispersed people in pre-Columbus America. The issue is also related to the question of the arrival of humans in the Americas. Was it a single migration of a homogeneous group of people across the Bering land bridge about twelve thousand years ago? If so, then the origin of the languages spoken in 1492 should be apparent. But extensive study has concluded that no Native American language has its roots in any historically known Old World language.

Linguistic comparative studies have shown that North American native languages can be grouped into at least fifty-six language families. But this does not mean that the languages in a linguistic family are similar. To see that, consider that English is in the Indo-European family, along with Russian, German, Polish, Persian, Hindi and many others. Admittedly, some of the American families did not have that many speakers. The language of the Karankawa was one such language family, but it was spoken by only eight to ten thousand people at its maximum.

So the question of why there were so many languages can also be stated as: "Why were there so many families spoken in America?" The answer to both questions is the same: we do not know. The origin of the languages seems to go far back into prehistory. The evolution of the Indo-European family is relatively well documented but traces back only about seven thousand years, while the peopling of the Americas happened between twelve thousand to thirty thousand years ago. By comparison, the diversity of languages in Europe in 1492 was much simpler than that encountered in the Americas.

So how did Native Americans communicate with one another? Pretty much the way we do today, by sign language. Indians developed a complicated system of signs, although there is no indication that the signs were universal. One of the more obvious hand signs was a line across the brow, which indicated "white man" because they usually wore hats with brims.

After the advent of European immigrants, a set of pidgin versions of English, French and Spanish were developed and used not only between the Europeans and native speakers but also between different groups of native speakers. Thus, pidgin English might serve as a rudimentary common language between Indian groups. The long trade routes used by the Indians attest to the fact that the Indians were very adept at communicating even with their language barriers.

A European learning an Indian language well was rare. Missionaries were one of the few groups motivated to be able to speak in the native language. One or two of the Spanish missionaries headed for the Texas Karankawa learned Coahuilteco while still in Mexico. The great difference between Karankawa and any other language is suggested by the example sentence below and two translations:

"Na'i amel ta kwiamoja aknamus."

"I hungry want bread eat."
"I am hungry; I want to eat bread."

Of the eight original Indian languages still being spoken today, Navajo is used by far more people, with some 150,000 current speakers. Still, we have adopted into our American vocabulary a number of words of Indian origin: raccoon, coyote, squash, potato, tapioca, chocolate, tobacco, canoe, moccasin, powwow and barbecue.

THE KARANKAWA WERE LONG-HEADED

Besides being described as tall, tattooed and beautifully muscled, the male Karankawa Indians of the Coastal Bend in Texas were characterized as being "long-headed." This trait was referred to in the ethnographic study by Albert S. Gatschet in 1891. The Karankawa would not be unique among the

American Indian groups in being described as long-headed. The Delaware and Algonquin were similarly noted.

The anthropological term for this cranium shape is "dolichecephalic," and it is differentiated from "brachycephalic," which is a broad, round head. You cannot interpret head shape too finely because there is quite a bit of variability even within a population group, as well as between groups. However, it turns out that almost all of the oldest fossil skulls found in the Americas are long-headed.

A celebrated long-headed skull belongs to Kennewick Man, found in Washington State in 1996 and carbon-dated at about 9,300 years old. A reconstructed face of Kennewick Man looks Caucasian and resembles the actor Patrick Stewart. A less well-known skull found in Texas at the Horn Shelter is similarly long-headed, as is Spirit Cave Man in Nevada. Most modern American Indians have round faces. This cranium shape is characteristic of the people from Mongolia.

Most of the other fossil skulls found in the Americas are in the age range of 7,800 to 10,800 years old. The oldest was actually found in 1959 in a suburb of Mexico City, only recently dated at 13,000 years old and also oval in shape. Although this skull dates from the end of the last ice age, it is still not old enough to represent one of the first Americans. The date of the first American immigrant is still being researched but is thought to be in the range of 18,000 to 30,000 years ago.

THE KARANKAWA WERE PEACEFUL AT HOME

A balanced and realistic picture of the Karankawa Indians is difficult to find. The views we have now reflect snapshots from individual Europeans and Americans from the period of 1528 through 1852. The Karankawa were not studied in an ethnographic sense until 1890, when they were long since extinct. And many of the first impressions came from the American colonial period after 1828, when the Karankawa were a fractured and dying people, not representative of their pre-European state. The Karankawa and their neighbors were first encountered by Cabeza de Vaca, who lived in their midst from 1528 through 1534. De Vaca's views of them were fairly benign and did not include cannibalism. Their population at that time might have numbered about eight thousand.

The next encounter with the Karankawa did not occur for 157 years, until the advent of the Frenchman Robert de La Salle and his colony in 1685. La Salle easily managed to antagonize the Karankawa and introduce European epidemic diseases. As a direct reaction to La Salle's incursion, the Spanish began to establish missions in Texas beginning in 1720. Then came the great influx of Anglo-European colonists starting in 1822, bringing intensive hostilities. The Karankawa were gone by 1852, their few survivors having fled to Mexico.

There were five different bands of Coahuiltecan Indians that constituted the Karankawa: the Coco, Cujane, Coapite, Copane and the Karankawa proper. The Spanish missionaries and the civil authorities could easily distinguish between these bands in the 1700s, although by the 1820s, only the Karankawa name was used in the historical record. The Spanish held the opinion that the Copane were trustworthy and the Karankawa were treacherous. The different Karankawa bands spoke their own dialects, and the Spanish missionaries noted some two hundred different Indian dialects in south Texas.

First impressions of the Karankawa were always shocking to Europeans. The men were tall, well muscled and naked or nearly so, with tattooed faces, pierced bodies and an overpowering stench from a dirty coating of alligator fat. They had somber or surly facial expressions and guttural voices, and they would not look you in the eye when they spoke—and they seldom spoke. They had no sense of your personal property, so they would tend to take what they wanted. However, they had a strong cultural sense of right and wrong and did not suffer injustice lightly. La Salle alienated them early by stealing one of their dugouts.

The Karankawa were very traditional and primitive hunter-gatherers habituated to survival along the coastal bays. They roamed from the coast to about fifty miles inland on a seasonal basis. They were very proficient in their use of the bow and arrow, even for fishing. Their diet consisted of various shellfish, fish, water birds, bird eggs, roots, berries, nuts and the occasional deer. They were not very adaptive, never making use of the horse or firearms. They adhered to their traditional lifestyle, spending only brief periods in the missions and abhorring the European concept of work, including farming and animal husbandry. A Karankawa couple would live with a small extended family group in "huts" that were built of bent willow poles, with only an animal skin or two hung as wind breaks. The men made fire from twirling two sticks together. The women cooked the food on an open fire or boiled in primitive clay pots. They loved their children excessively and mourned a death for a year. They readily adopted captive French children.

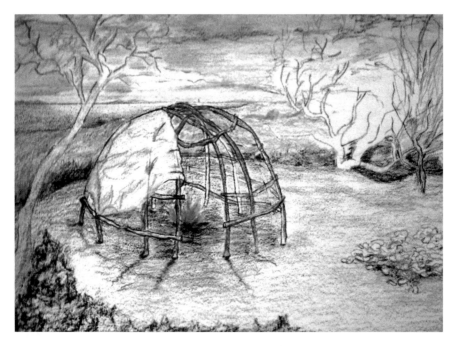

A Karankawa Indian hut. *Artwork by Veronica Koenig, 2011.*

They had small, voiceless dogs with pointed snouts like a fox. One of the names that other bands had for the Karankawa was "dog lovers." Another was "no moccasins" and "walks on water." For fun, the Karankawa men liked to wrestle and have shooting contests. Their skill was so great that they could make one arrow split another. They had a sense of humor, but it seemed strange to Europeans. The Karankawa men (but not the women) wore body adornments of beads, shells and feathers in their hair and ears.

The Karankawa each had a secret name that they would never reveal to outsiders, but they took Spanish or American nicknames, like Prudentio or Captain Jack. They had an extensive sign language that they used with other bands and with the Spanish and Anglo-Europeans. They used a sophisticated system of smoke signals in which the column of smoke could be made to ascend in twenty different ways. The view that emerges from their three-hundred-year history with Europeans is of a simple and primitive people, well adapted to a way of life that had served them well over many years but unwilling to adapt or accept European customs and beliefs. They paid dearly for their intransigence.

Part II
THE SPANISH COLONIAL
PERIOD, 1519–1811

THE FIRST EUROPEAN BABY IN TEXAS WAS FRENCH

France had a good claim to Texas, as good as its claim to Louisiana. In 1685, the first settlement in Texas was established by a Frenchman, Robert de La Salle. This settlement was later called Fort St. Louis. Spain had claimed Texas (as New Spain) since Columbus and had sent several expeditions to Texas, such as Álvarez de Pineda's in 1519 and Francisco de Coronado's in 1541. But Spain had failed to establish any permanent settlements in Texas by 1685. San Antonio was not founded until 1718. So, the French used La Salle's short-lived colony as their basis for a claim to Texas territory.

La Salle's expedition of three ships and 280 settlers overshot the Mississippi River and landed at Matagorda Bay on February 20, 1685. One of the three ships wrecked immediately trying to get through Pass Cavallo, and one ship returned to France, as planned. The third ship, *La Belle*, eventually grounded and sank in the bay, stranding the settlers. La Salle built a camp on Garcitas Creek that he considered to be only temporary until he could locate the Mississippi River. Fort St. Louis was not a fort at all, having only one building made from a ship's timbers and no palisade. But the French were able to transport eight iron cannons from the wrecked ship to the settlement site, where they sat on the ground. La Salle was audacious but incompetent, erratic, contentious and arrogant—and that is what his *friends* might have said about him, if he had had any. The colonists led a miserable existence,

with about half of them dying within six months due to malnutrition, overwork, disease and cruel treatment by La Salle. But they hung on, and the first European child was born there in 1688. The Karankawa killed all the remaining adult French settlers at Fort St. Louis in late 1688, while sparing and adopting five French children.

The Spanish learned of the La Salle settlement in 1685 from captured French deserters and were inflamed into action. One of the actions was to send a series of military expeditions to find the settlement. A tenth expedition under Alonso de Leon eventually reached the French settlement on April 22, 1689, only a few months after it was exterminated by the Karankawa. The captured French children were later ransomed from their adopted Karankawa parents. In 1690, Alonso de Leon returned to the site and burned the few derelict buildings. The site lay abandoned until the 1720s. However, in other parts of Texas, Spain started an initiative of outposts based on the presidio-mission system. One of the first was San Francisco de Los Tejas in east Texas in 1690.

The French heard the story of La Salle's colony from the few survivors who made it back to France, and in the 1720s, they determined to reassert their

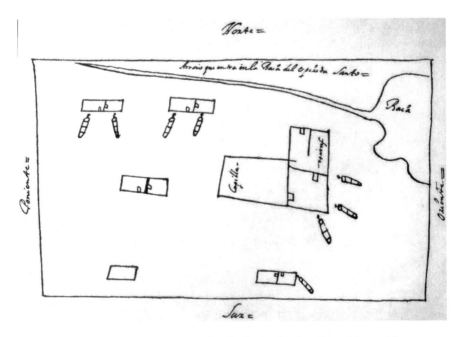

The plan of LaSalle's camp, later called Fort St. Louis, showing the positions of the buildings and the eight iron cannons on the ground. The sketch was made by a member of the Alonso de Leon expedition in 1869. *From texasbeyondhistory.net.*

claim to Texas. They sent several naval expeditions to find the settlement site, which at that point they knew less about than the Spanish. In 1720, Captain Jean Beringer overshot Matagorda Bay and landed in Aransas Bay. The next year, an expedition captained by Bernard de La Harpe fruitlessly sought La Salle's settlement site at Galveston Bay. The Frenchman Louis de St. Denis planned a land and sea invasion of east Texas from Louisiana.

Spain's response to these incursions was a major occupation effort in Texas, including a presidio and mission at the Fort St. Louis site. On April 4, 1721, a presidio was established and named Nuestra Senora de Loreto de la Bahia del Espiritu Santo, and three years later, a mission was built on the other side of Garcitas Creek. Both mission and presidio had to be moved within a few years because of the hostile environment and the Indians.

The Fort St. Louis/Presidio la Bahia site has received great archaeological interest. The buried French cannons were discovered in 1996. A recent subsurface study by the Texas Historical Commission located the sites of the original La Salle buildings, as well as the more extensive fortifications of the 1721 Spanish presidio, which housed about one hundred soldiers. The Fort St. Louis site was characterized by failure, death and hardship, but it was the geographical focus where France and Spain faced off for possession of Texas. Both were willing to fight for it, but the French could never find it again.

Álvarez de Pineda Explored the Gulf Coast Five Hundred Years Ago

Texas was claimed for Spain almost five hundred years ago. At that time, Ponce de Leon had explored Florida, and Hernán Cortés was in Mexico preparing to conquer the Aztec empire. But the Gulf Coast between Florida and the middle Mexican coast was unexplored and unsettled. There was conflict in the Spanish royal court and in Mexico between the various competitors and would-be conquistadores over the parts of New Spain that would be granted to them. Further, the Spanish believed that there could be a sea passage from the Gulf of Mexico to the Pacific and thereby a route to Asia. So there was plenty of incentive to explore the north shore of the Gulf.

Alonso Álvarez de Pineda accomplished that in 1519. Álvarez was already experienced in Gulf Coast exploration, having charted the region from the Yucatan to the Rio Panuco, just north of Vera Cruz. In 1519,

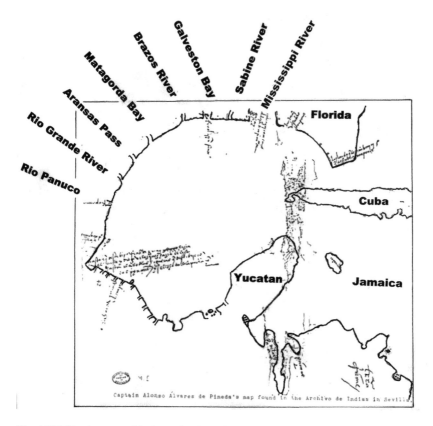

The 1519 Pineda map, with the author's conjecture of the identities of the cuts representing rivers and bays along the Gulf shoreline from Florida to Mexico.

the governor of Jamaica, Francisco de Garay, gave Álvarez de Pineda command of four ships to explore the north coast of the Gulf from Florida to Mexico. His experienced pilot was Anton de Alaminos. The historical record gives almost no information about the life of Álvarez de Pineda, and he did not write a report of his voyage. But as a result of this exploration, in 1519, Álvarez produced the first accurate map of the Gulf from Florida to the Yucatan, known as the *Pineda Map*.

Álvarez de Pineda left Jamaica in early 1519 and first attempted to sail around Florida, which was then erroneously believed to be an island. Finding no passage from west to east, Álvarez concluded that Florida was a peninsula. Turning west, on June 2, 1519, Álvarez became the first European to see the discharge of the Mississippi River and recognized it as a very large river. He named it Rio del Espíritu Santo but did not enter. About 160 years

later, in 1682, La Salle descended the Mississippi River to its mouth at the Gulf, and this exploration gave France its claim to the Louisiana territory.

Álvarez continued his journey west, exploring the coastal passes and bays, seeking the passage to the Pacific. His exploration of the shore area found "very good land," ports, rivers and peaceful Indians. Álvarez reached the Rio Panuco in Mexico after a voyage of six to eight months. In the fall of 1519, he returned to Jamaica, gave his report to Garay and produced his historic map of the Gulf. The map was later presented to the Spanish king, Charles V. Álvarez had correctly shown that the Gulf Coast was continuous from the southern tip of Florida to Mexico, with no passage to the Pacific.

Álvarez de Pineda's map has few details but does show rather accurately the main features of the Gulf: Florida, the Mississippi, the Yucatan Peninsula and the islands of Cuba and Jamaica. The map may have shown La Isla Blanca (Padre Island) but no other barrier islands or any bays. The coastline west of the Mississippi is cut by six sets of parallel lines, which could indicate passes through the barrier islands or mouths of rivers that Álvarez explored. Legend has it that Álvarez discovered Corpus Christi Bay and named it for the feast day on June 24, 1519. Garay sent Álvarez back to the Rio Panuco with three ships and 240 soldiers to establish a settlement. The Huastec Indians turned hostile, overwhelming this settlement and "killing all the horses and soldiers except sixty," who escaped to the port of Vila Rica. Álvarez de Pineda and his mother, Nina, were among those killed. The City of Corpus Christi recognizes the achievements of Álvarez de Pineda with a statue and a "Plaza de Pineda."

There is a part in Álvarez de Pineda's oral account of his Gulf Coast voyage that suggests that he had some contact with the coastal Indians. He described some as wearing gold jewelry and some that were giants, more than seven feet tall. This latter reference might indicate that somehow Álvarez de Pineda encountered the Karankawa.

TRAGICOMEDY OF LA SALLE'S COLONISTS AT FORT ST. LOUIS

La Salle has been correctly faulted for the gross mismanagement of his short-lived colony in Texas near Matagorda Bay, later called Fort St. Louis. His bad judgment started in France in the selection of the personnel to accompany

him to the New World. Of the 280 who would make the trip to Texas in 1685, about 100 were soldiers. The rest included artisans, adventurers, a few farmers, priests, young men and boys, 6 women and only one family, the Talons. Few had any wilderness (let alone practical) experience. Of this number, 5 adults survived and made it back to France, and 5 children were adopted by the Karankawa to be later ransomed by the Spanish. The desperate efforts of the colonists to survive in the Texas wilderness had elements of comedy due to their inexperience. But ultimately, almost all died at the site, and their story was quite tragic.

The biggest problems for La Salle's colonists started when they reached Matagorda Bay. One was the placement by La Salle of his settlement on Garcitas Creek, a site several miles from the coast and devoid of timber and a fresh water supply. Much of their food sank with the supply ship, *Amiable*. Then La Salle loaded most of the remaining food on the last ship, *La Belle*, which he put in the care of a notorious drunk. This left the colonists with almost nothing to eat, forcing them early to hunt and farm. They could get no help from the Karankawa because La Salle had alienated them. The work to provide shelter was so strenuous, the food so meager and La Salle's treatment and punishments so harsh that half of the colonists died within six months.

There were large bison herds on the plains opposite the camp on Garcitas Creek, but none of the colonists knew how to stalk and hunt. On the first day, one colonist got off a single shot at the bison before the French dogs ran barking at the bison and drove them away. The next day, they left the dogs back in camp. In the midst of five to six thousand animals, the French hunters crawled on hands and knees until raw and bleeding to get close, but the bison would catch their scent and flee. Finally, the French were able to shoot some animals, but without bringing them down. At the end of one frustrating day, the French came upon one bison still kicking that had fallen unseen. At this point, the French found that they had no one who knew how to butcher it. Desperate for meat, they hacked it up far into the darkness and then got lost trying to find their way back to camp.

Thereafter, the French hunters gradually learned the skills to bring a bison down. There were other lessons to be learned (the hard way). Once, as a wounded bison was hobbling away on three legs, one of the French clerics attempted to turn it back by standing in front of it. The enraged, wounded beast charged him, and impeded by his cassock, the cleric was run down and trampled. On another occasion, a cleric struck a downed bison in the head with his rifle butt. The animal revived, rose up and again chased the

cleric down and trampled him. Colonists were continually getting separated and lost, spending terrified nights in the forest before they could find their way back to camp. This was highly dangerous since individuals and small groups had been repeatedly ambushed by the Karankawa lurking near their camp. Attempts at farming were likewise frustrated. The plantings of beets, celery, asparagus, chicory, pumpkins and watermelons came up, but the pigs ate them due to the lack of fencing. Only the pigs at Fort St. Louis thrived.

The final tragedy at Fort St. Louis involved the Spanish attempts to find La Salle's colony. In 1688, a Spanish ship finally found the wreck of the *La Belle* in Matagorda Bay but could discover no clue to the nearby colonists' camp. Had the remaining colonists been found and captured, they would have been saved. As it was, they were massacred by the Karankawa within a few months. By that time, La Salle had been assassinated in east Texas, and the few colonists with him continued on their way to Canada and France.

THE TENTH AND FINAL EXPEDITION TO FIND LA SALLE

The Spanish were frantic to find and destroy the French colony established in Texas by La Salle in 1685. By 1689, there had been four unsuccessful overland expeditions and five by sea. The Spanish knew the approximate site of La Salle's colony from a captured Frenchman who had arrived with La Salle, but its location, up a creek off Matagorda Bay, was elusive. The French had also tried unsuccessfully to rediscover the colony in four sea expeditions. But the Texas Indians knew where it was and what had happened there.

In 1689, Alonzo de Leon mounted another land expedition, his third try. This time, he had the assistance of a fifty-year-old Frenchman, Jean Gery, who had been sent by La Salle five years earlier to "pacify" the Indians living near the Rio Grande. Gery had been captured in the Uvalde area by the Spanish and pressed into service as a guide and an interpreter. Gery proved more valuable as an interpreter than as a guide for he spoke several Indian languages and was widely known and revered. De Leon started off on March 23 from Monclovia with a huge force composed of eighty-five armed soldiers, another twenty-five drovers, seven hundred horses, two hundred cows, five hundred pounds of chocolate and three mule loads of tobacco. De Leon was prepared either to negotiate (or eat) or to fight.

As the Spanish expedition approached the crossing of the Rio Grande, De Leon encountered a Quem Indian who had recently spent a week at La Salle's camp while searching for his kidnapped wife. He agreed to sign on as another guide. Then, in crossing the river, the Spanish were surprised to be met by a group of five hundred Indians there to welcome their old friend, Jean Gery. At least five Indian "nations" were represented, some from as far away as two hundred miles. How did they do that? The long-distance communication among the dispersed Texas Indian groups was astonishing.

Gery was accorded the place of honor, and De Leon provided gifts of blankets, beads and knives, as well as cattle for the welcome feast. The Spanish eyed the sixteen dried human skulls that hung in plain view, but this was the largest force of Spanish military ever seen by Texas Indians. With their guides, the Spanish expedition was able to move fast, traveling twelve to eighteen miles a day, along a route that was visibly well used by Indians on trading or raiding missions. Their route was inland, passing near present-day Crystal City, Jourdanton, and due east to Cuero, before turning south.

The expedition did not encounter a single Indian after the five nations on the Rio Grande until they came upon one near the crossing of the Guadalupe River. The unafraid Indian provided the first intelligence to De Leon that the French colony had been annihilated "two moons" (two months) earlier. A vanguard of sixty soldiers moved forward to another Indian village. These Indians met the Spanish with the greeting "Tejas, Tejas" ("Friends, Friends") and knew the whole story of the French colony. The colonists had been decimated by smallpox and typhoid fever before being killed by the coastal Karankawa. At this and another Indian village, De Leon found French clothing, a Bible and other items looted from the French camp. So De Leon knew the location and the story of the La Salle colony from the Indians well before he got there.

Reaching the colony site on April 22, 1689, De Leon found five small, scattered buildings and three corpses. There had been only 25 colonists left from the initial 280 when La Salle abandoned the colony in early 1869 to seek "help." The Spanish buried the dead along with the armament of the "fort"—eight iron cannons found lying on the ground. These cannons would be rediscovered in 1996 by archaeologists, confirming the location of Fort St. Louis. The only French life from the colony was found in the fenced garden, where asparagus, endives and corn still grew. The surviving French missed a Spanish capture and rescue by only two months.

Amazingly, the Indians in the vicinity of Fort St. Louis recognized Jean Gery. The charisma of this Frenchman among such widely dispersed Indian

bands astounded the Spanish. The invaluable help of the Indian guides and villagers was rewarded by gifts of horses, tobacco and chocolate. This story illustrates one thing especially: to get the right answer, you need to ask the right question of the right person. The Spanish finally asked the right people, the Indians.

TEXAS INDIAN POPULATION WAS LARGE IN 1800

So, how many Indians were there in Texas at the beginning of the Anglo-European immigration? In fact, there were more than we might imagine; the number may have been in the range of 350,000 to 1 million. Moreover, that number was a lot fewer than when Christopher Columbus arrived in the New World in 1492. Anthropologists, archaeologists and historians have been trying to estimate the native population of the Americas in 1491, but the lack of written records has made the subject one of much debate. They have had to make do with early explorers' accounts, estimates of the effects of European epidemic diseases, and other surrogates for population. The higher end of pre-Columbian estimates for North America is in the range of 10 to 20 million. The estimates for mortality from epidemic diseases have been up to 90 percent for the three hundred years following European colonization. So, in 1800, the native population was a fraction of its original numbers.

The anecdotal evidence for depopulation comes from early Spanish explorers like Cortés, De Soto, Francisco Pizarro and others, who noted the outbreak of epidemics and the disappearances of whole villages. The first epidemics were not long in coming. Smallpox appeared among the Inca in Mexico in 1524, although it had probably already appeared in the Caribbean Islands. The diseases were able to race ahead of the Europeans by means of already infected Indians, but contact with infected Europeans was not required. Since almost all of the epidemic diseases had a domesticated animal origin, contact with the pigs and cows brought to the Americas might have been enough. In Texas, the first smallpox outbreak was associated with La Salle's settlement at Fort St. Louis in 1688. Inadvertently, the Spanish missions of the 1700s were sites of contagion where hunter-gatherer Indians assembled in close quarters with Europeans and their animals.

To be sure, a population estimate for Indians in Texas would be imprecise. Besides the epidemic diseases, there was also the immigration of other Indian

groups from the north, northwest and east. The Comanche moved south into Texas in the 1700s and displaced the Apache to the west. Some eastern tribes like the Cherokee and the Creek moved from the east into Texas. A search of historical records found a surprising six hundred Indian tribal names in Texas for the four hundred years from 1500 to 1900. Most of us now could name only a few of these, like the Karankawa, Caddo, Tonkawa and Wichita, in addition to the better-known Comanche and Apache.

The *New Handbook of Texas*, printed in 1996, listed all six hundred of the Indian tribe names alphabetically, from Aba to Zorquan. Michael Collins surveyed the historical references for the tribal names and classified them by the century of the reference and their location in seven geographical divisions of Texas. Included were a number of important tribal names most people would not recognize. For example, the Akokisa of the eastern Gulf Coast were mentioned in the historical record for four hundred years and the Bidai from the same region for three hundred years.

It is not possible to go from this multiplicity of Indian tribal names to any kind of population estimate because it is unknown if the name refers to a band, a group or a tribe. So, the numbers associated with each name might range from as few as 100 to 10,000. It is known that the Comanche and the Caddo tribes had populations in excess of 10,000. Robert Ricklis estimated the Karankawa to number about 2,000 in 1800, down from a figure of 8,000 in 1700. However, the plethora of tribal names in Texas does argue for a large population. Anglo-European settlers in Texas might have been entering a land with between 350,000 and 1 million people. But the dispersed hunter-gatherer lifestyle of the Indians just made the land seem only sparsely settled.

THE MISSION AND PRESIDIO LA BAHIA MIGRATED INLAND

The mission and the Presidio la Bahia moved three times before ending in Goliad in 1749. The first location was on Matagorda Bay, which accounts for the early name La Bahia. The name moved with them to the town of Goliad, far from the coast. The Spanish explorer Alonso de Leon discovered the site of La Salle's colony and built a presidio on the same spot to prevent a return of the French. The Presidio la Bahia was founded in April 1721. The

mission, Espíritu Santo (from Nuestra Senora Espíritu Santo de Zuniga), was established nearby in 1722.

Like the doomed French colonists at this site, the Spanish suffered from the same hardships: unhealthy environment, hostile Karankawa Indians and crop failures. In 1725, after clashes with the Indians, the mission moved ten leagues (thirty miles) west to a site on the Guadalupe River in present-day Victoria. Then, in 1726, both the mission and the presidio moved to a new site on the Guadalupe River above Victoria. At this site, the mission successfully implemented a system of dry farming when efforts to dam and irrigate from the Guadalupe River failed. Here, the mission prospered for twenty-six years, raising enough corn and hay to export to the settlements in Bexar and east Texas and, more impressively, large herds of cattle and mustang horses.

In 1749, the mission and the Presidio la Bahia were moved a third and final time by a decree from the Spanish viceroy. This last site, called Santa Dorotea, was on the San Antonio River in present-day Goliad, and the move was ordered to protect the main road between Mexico and Bexar. By February 1750, the presidio was situated on a hill overlooking the San Antonio River and staffed with twenty-nine men. The presidio had a barracks, forty jacals (or huts) and its own church, the Chapel of Our Lady of Loreto. The Loreto Chapel has been in use since its founding and still holds Mass today. The chapel was described as being twenty varas (fifty-five feet) long and seven varas (nineteen feet) wide, almost exactly the same dimensions as the church that would be built at the mission in Refugio in 1804. The settlement of La Bahia grew up around the presidio. The first Declaration of Texas Independence was signed inside the Loreto Chapel on December 20, 1835.

The Mission Espíritu Santo was built across the San Antonio River to keep the soldiers separated from the Indians. In its migration, the mission changed its focus from the difficult Karankawa to the more amenable Aranama and Tonkawa Indians. The Indian population in 1758 was about 180 men, women and children. The Espíritu Santo Mission is recognized as the first great cattle ranch in Texas, with herds numbering at about forty thousand. These herds attracted Apache and Comanche raiders. Indian attacks and secularization by the Spanish/Mexican governments caused the mission to be abandoned by 1830, and it soon fell into ruins, to be reconstructed in the 1930s.

The presidio survived but was less successful as a fort, since it was overcome several times. The first siege was by the Texan freebooters under

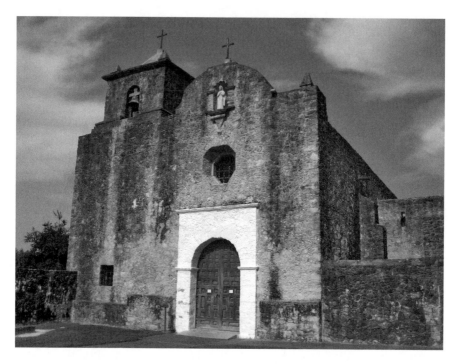

The Loreto Chapel in the early 1900s, the only surviving part of the Presidio La Bahia. *Travis Witt and Wikimedia Commons.*

Guiterrez and Magee in 1812. They captured the presidio in November 1812 and held it for about three months in the name of the first Republic of Texas. In 1817, another freebooter force under Henry Perry was repulsed. But in 1821, James Long surprised the garrison and held the fort for three days. In the early days of the Texas Revolution in October 1835, Benjamin Milam captured the presidio from its twenty-four-man Mexican garrison. The fort was abandoned by James Fannin in March 1836. By 1846, the presidio was in ruins except for the Loreto Chapel.

THE STREETS OF SAN ANTONIO WERE ALWAYS CROOKED

Crooked, angular streets were remarked on by three independent visitors to Bexar (San Antonio) in 1828. Worse, the chaos of the streets was seen as a metaphor for the indolence of the inhabitants and the neglect of the Spanish/

Mexican governments. This was despite the fact that San Antonio was the de facto capital of Texas and the seat of the provincial government. It was also the principal garrison of Spanish/Mexican troops in Texas, some five hundred men. San Antonio was more than one hundred years old at that point, having grown up around the San Antonio de Bexar Presidio in 1718.

Two of the visitors to Bexar were part of the entourage of General Manuel de Mier y Terán on his inspection tour from Mexico City: the Frenchman Jean Louis Berlandier and the Spaniard Jose Maria Sanchez. They spent from March 1 through April 13, 1828, in Bexar before departing for Nacogdoches. Both Berlandier and Sanchez kept detailed diaries of their time in Bexar, and the first comments that they made were on the crookedness of the streets. Perhaps they were comparing Bexar to the orderly geometric pattern of other Spanish settlements in the New World, with a large, square central plaza containing the church and principal government buildings, surrounded by rectilinear residential streets. What they found instead was a jumble of streets around an unremarkable square. Most of the houses were jacals, or huts, with wooden stakes for walls and thatched roofs. Berlandier noted that the few stone houses were of "heavy and coarse construction...Bexar resembles a large village more than the municipal seat of a department. There is no paved street and no public building." Its population in 1828 was static or declining at about four thousand. The five nearby missions had been "secularized" and were abandoned ruins.

Both Berlandier and Sanchez remarked on the complete lack of industry among the residents of Bexar. Sanchez said, "The character of the people is care-free, they are enthusiastic dancers, very fond of luxury and the worst punishment that can be inflicted upon them is work." Although the land was rich, there was very little agriculture. Berlandier observed, "I have often seen them go elsewhere, sometimes even to the Anglo-European colonists to seek the grain necessary for their sustenance...When they are reproached for their indolence, they allege that the Indians do not allow them to go out to cultivate the fields" or raise domestic animals. Yet Berlandier noted that the same obstacles face the Anglo-American settlers of the Stephen F. Austin colony.

The third visitor was an American traveler named Joseph Clopper, a twenty-six-year-old single man who arrived in Bexar with his father in the summer of 1828. From a distance, Clopper was charmed by his first view of Bexar. But upon seeing it close up, "He looks with mortification and disgust at the order of architecture...He crosses the river and beholds the same wigwam style of building which constitute the principal part of town. He proceeds on, finds that the streets intersect each other very irregularly." He

noted that there is not a single pane of glass in the whole town and that the windows were like portholes.

However, young Clopper was more interested in the girls in Bexar than the architecture or the economy. He became a favorite of their landlady, who had two pretty daughters. With them, he was able to attend several of the fandangos (dances), although he spoke no Spanish. He was surprised to see that in the dancing, the women made the choice of the male dance partner. If one man were chosen by more than one woman, "there is a good deal of elbowing among the fair ones. Delicacy forms but a small part of female character in San Antonio." Clopper was "often solicited, but never participate[d]" in the dances. But as he departed, Clopper was invited by his landlady to return in two or three years, when her prettiest daughter would be of marriageable age.

THE CHURCH AND THE JACALS OF REFUGIO MISSION IN 1795

The Refugio Mission church in 1795 consisted of two nearly equal-sized stone chapels at the opposite ends of an L-shaped building. There are no drawings or paintings of the Refugio Mission from its time, but there is a narrative description. The church buildings, the convento (rectory) and the jacals (wooden stake huts) were described in detail in a comprehensive inventory made in 1796. The altars and interiors of the chapels at Refugio Mission were richly decorated with religious statues and paintings. This inventory showed that the mission was surprisingly well furnished with tools, books, food, china, wine, brown sugar, tobacco, chocolate and live stock, despite having only moved to the Refugio site in 1795.

The two chapels were separated by a sacristy room about fourteen feet square, forming the corner of the "L." The chapels and the sacristy all had red tile floors. The sacristy was dominated by a large six-drawer chest of drawers in one corner, with each drawer having a lock and key. The contents of each drawer were inventoried in exhaustive detail. They were filled with the religious items not in use in the two chapels: vestments, chalices (two in gold-plated silver), altar cloths (ten in all), chalice veils (fifty-six in all), a wooden tabernacle and so on. On either side of the chest of drawers were two painted closets filled with other religious items: twenty-three brass

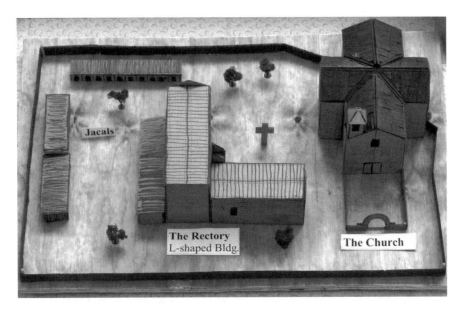

The author's reconstructed model of the Refugio Mission as it appeared in about 1816, showing the stone mission church, rectory buildings, the Indian jacals and the stockade.

candleholders, four crystal basins with gilt edges, holy oils, breviaries and two tin shields for confessionals. In one corner of the crowded sacristy was a brass shell or basin used for baptisms and in the other a washstand (lavabo) for use by the priest before Mass. Some of the religious articles at Refugio were being stored for eventual use by a proposed new mission to be called Holy Trinity.

Against the outer wall of the sacristy and one of the chapels was the convento or rectory, an adobe jacal fifty-two feet long and twenty feet wide. It had adobe walls, a dirt floor and a grass roof but a door with a lock and key. This was for missionary living quarters and storage. In this jacal were seven chests that contained all the hand tools, bundles of tobacco, barrels of Mass wine, sacks of brown sugar, a guitar, a violin, a world map, maps of Europe and Asia, a genealogical tree from the time of Adam and Eve to the time of Christ, china ware, cutlery and items to be used as gifts for the Indians. There were also two large bookcases containing more than one hundred volumes.

In addition to this adobe jacal, there were eleven other wood-stake jacals arranged around a courtyard. Other residential jacals, occupied by the Indians and soldiers, lined the stockade walls. Three of the mission jacals had doors with locks and keys. There were about sixty-five Indians

in residency at the mission in this period, although the number fluctuated seasonally. All of the jacals were made of wooden stakes with grass roofs and dirt floors. The eleven mission jacals were named as follows: an office, a blacksmith shop, a carpentry shop, a work animal shop, two kitchens, three more storage huts, a cow shed and a chicken coop. No dimensions were given, but the office jacal must have been large because it stored big, bulky items (e.g., 133 pounds of iron, 85 pounds of steel, six bushels of salt, nine hundred weights of corn, 75 pounds of beef tallow and ninety-four straw hats). In one of the mission jacals was stored 112 pounds of chocolate under lock and key. In the yard were fruit trees and about ninety fowl, and in the surrounding fields were 2,900 head of stock, including cattle, horses, oxen, sheep and goats.

All of these furnishings and supplies were brought up by mule train from Zacatecas in Mexico. A major item of resupply for the mission over its history was tobacco and chocolate for the Indian residents. The inventory of 1796 shows that the Franciscan missionaries did not lack for material support.

FEW TOWNS IN TEXAS UNTIL AUSTIN'S COLONY

There were few towns in Texas before those founded by the colonists who came with Stephen F. Austin. Austin was the first empresario to receive a Mexican contract allowing non-Hispanic emigrants into Texas. Before 1822, there was only San Antonio and the settlements around the Spanish missions and presidios, built in the period from 1690 to 1795. In 1744, there were only about 1,500 Hispanic inhabitants in Texas, mostly living around San Antonio de Bexar. San Antonio was started in 1718, a settlement clustered around the San Antonio de Bexar Presidio. Spain tried colonizing Texas with missions and presidios to counter the French claims to Texas based on the La Salle colony of 1685.

Besides San Antonio, there were only the settlements at Nacogdoches and La Bahia (Goliad). Six missions were founded around Nacogdoches in 1718, but their existence was tenuous. They were abandoned in a few years, and most of the Spanish settlers moved back to San Antonio. La Bahia (Goliad) was founded in 1749 when the mission and presidio moved there from the coastal area. El Copano was a landing for La Bahia and San Antonio, but no one actually lived there until 1840.

Spain had abandoned the mission system by 1800, and the population of Texas was only seven thousand when the first Austin colonists began to arrive in 1822. The flood of immigrants brought the Anglo-European population of Texas to about thirty thousand by 1835, on the eve of the Texas Revolution. That flood had continued with Mexico unable to control the influx even after it nullified its liberal colonization laws in 1828. The colonists started new towns at their entry ports and at many river crossings and ferries. These towns numbered more than thirty by 1835, but most had populations of one hundred or less, with the majority of people living out on their farms.

The largest by far of the new towns was San Felipe de Austin, the capital of the Austin colony. Austin established his town in 1823 at a crossing on the Brazos River, where there was already a ferry operating. By 1828, the population of San Felipe was two hundred, living in about fifty log cabins, with three stores, two taverns and a hotel. Three steamboats traversed the Brazos as far up as San Felipe, and the first crop of cotton for export was shipped from there. The population of San Felipe reached six hundred in 1835, second only to San Antonio.

Some Austin colonists began to arrive while Austin was still trying to get the new Mexican government to recognize the empresario contract given to his father, Moses. Most of these settlers came in through the Brazos River entry port, twenty-five thousand in all. Fort Bend, later Richmond, was a blockhouse built in 1822 at a large bend in the Brazos River. East Columbia was founded as a port on the Brazos by Josiah Hughes Bell in 1823, first known as Bell's Landing. Bell also founded West Columbia a few miles away in 1826, which served for the first year (1836) as the capital of the new Republic of Texas. Washington-on-the-Brazos was founded in 1824 at the La Bahia ferry crossing. By 1836, with residents there numbering one hundred, the town became General Sam Houston's headquarters. Harrisburg was founded in 1826 on the Buffalo Bayou, later incorporated into Houston. Lynch's ferry was twenty miles away and had been in operation since 1822. Both Harrisburg and Lynch's ferry figured prominently in the Battle of San Jacinto.

The empresarios started their own towns. Victoria was founded by Martin de Leon in 1824 and had three hundred people living there in 1834. Gonzales was founded and abandoned several times. It was first founded by Green DeWitt in 1825 and then abandoned a year later due to Indian attacks; it was rebuilt in 1827 and then burned by Sam Houston in 1836. San Patricio was founded by the empresarios James McGloin and John McMullen in 1829 at the Atascosito crossing of the Nueces River.

Some other prominent towns in pre-revolutionary Texas were Matagorda at the mouth of the Colorado River (1827); Mina, later called Bastrop (1830); Anahuac on Trinity Bay (1830); Velasco, near the mouth of the Brazos River (1831); Texana (1832), originally named Santa Anna; and New Washington (1835), later called Morgan's Point.

Many of these new towns were abandoned and burned in the Runaway Scrape, the frantic flight of colonists in the spring of 1836. Some never recovered. But immigration and the growth of towns accelerated during the Republic of Texas. The population of Texas in 1845, the year of statehood, was 125,000.

What Do We Really Know About the Karankawa?

Most of what we know about the Karankawa Indians comes from the first-person accounts of the Europeans and Americans who encountered them in the historic period from 1492 to about 1850. The Karankawa had no written language, and there is no record of an oral history. It seems that none of them entered Anglo or Mexican society. They were not studied until 1888, long after they were extinct. We now know something of their material culture from archaeological studies that have been conducted over the last fifty years, but this does not tell us what they were like as a people. Their story has been pieced together from the many, often conflicting, first-person accounts. The one word image that we have is that they were "cannibals." Yet their story continues to fascinate us.

The first European to encounter the Karankawa was Cabeza de Vaca, who from 1528 spent eight years among the Indians of Texas on his trek back to Mexico. De Vaca encountered at least twenty-three Native American tribes in his Texas journeys, and historians have identified five of these as members of the Karankawa group: Coco, Cujane, Copane, Coapite and the Karankawa proper. The identification of five separate Karankawa groups is significant because this distinction was lost by 1830. The Coco saved the lives of the shipwrecked and marooned Spaniards near Galveston Island in 1528. De Vaca reflected a fairly benign view of the five Karankawa tribes and did not mention cannibalism except to say that the Coco were horrified when the Spaniards resorted to cannibalizing one another in the winter of 1528.

The next Karankawa encounter with Europeans was with La Salle and his colony on Matagorda Bay in 1685. The initial good impressions went sour when La Salle stole a dugout canoe from the nearby band. Relations between the French colonists and the Indians were hostile until the colony was wiped out in 1688. But the Indians spared the French children, adopting them into the tribe until they were later ransomed. The first European epidemic diseases struck the Karankawa near the La Salle colony site in 1688.

In reaction to La Salle's incursion into Texas, the Spanish began to build a series of missions and presidios across Texas, the first in 1690. The mission and Presidio la Bahia was established at La Salle's site in 1721. Inadvertently, the missions became sites of contagion with the European epidemic diseases. In 1767, a Spanish cleric, Fray Gaspar Jose de Solis, made an inspection journey to all the Texas missions. On the basis of a week's stay at the Rosario mission near Goliad, De Solis was able to conclude that all five of the Karankawa bands were barbaric, cannibalistic, dissolute and barely worthy of the missionaries' efforts. It does seem that the Karankawa practiced ritual cannibalism on captive warriors, the same as done by almost all other Texas tribes.

During the late 1700s, the distinctions between the five Karankawa bands began to fade away. In this same interval, the populations of the five Karankawa bands declined by 75 percent, mainly due to epidemic diseases. Due to the great population stress, the Karankawa groups may have started to merge and their separate cultures disintegrate. By the time of the Anglo immigration with Stephen F. Austin in 1822, the Karankawa population had declined even more, to about 5 percent of its number at the time of La Salle.

There were quite a number of encounters between the Anglo-European colonists and the surviving Indians, who were identified only as Karankawa by then. Some of these were friendly, and some were murderous. Although there were episodes of peaceful cohabitation between Karankawa and colonists, there was no effort at reconciliation. There was simply no room for the Karankawa in Anglo-Texas. They were in the way, and the Karankawa were not disposed to adapt to the new reality.

So how should we judge the Karankawa? It would seem inaccurate and unfair to judge them solely by the actions of the small remnants of their original five groups. Nor should we judge them by the opinions of the Spanish missionaries, who had their own agenda for the Indians. Perhaps the most characteristic judgments should be made from the early experiences of Cabeza de Vaca.

Part III

MEXICAN TEXAS, COLONIZATION AND REVOLUTION, 1811–1836

TERÁN AND ALMONTE: SPIES FROM MEXICO CITY

Texas underwent intense scrutiny by two military men sent from Mexico City before the Texas Revolution. Their real purpose was to assess the revolutionary spirit among the Texan colonists, but they had other cover stories. They learned much during their extended visits to Texas, so much that they became the "experts" on Texas. But their findings led them to recommend only the traditional Mexican solution to dissent: crush it by military force. Perhaps armed conflict was the only solution in Texas since both sides were too far apart to reconcile their cultures and worldviews.

General Manuel de Mier y Terán was the first of these two to visit Texas in a nearly yearlong stay from February 1, 1828. He was the head of a boundary commission sent to examine the ill-defined Texas-Louisiana border. This border was the site of illegal immigration and contraband from Louisiana into Mexican Texas. The illegal immigration involved both American settlers and also "peaceful" Indian groups, such as the Cherokee, being pushed west and south. Terán went first to San Antonio de Bexar, where he spent several weeks before the long trek to Nacogdoches, arriving there on June 3, 1828. Along the way, Terán spent two weeks as Stephen F. Austin's guest in San Felipe. Terán reported through long letters to the president of Mexico and also kept a detailed diary. He already had his recommendations in mind as he was leaving

Bexar, so nothing that he saw in the rest of Texas changed his views. They were to stop American immigration and influence, send more Mexican troops to Texas to quell the Americans and move five thousand Mexican settlers from Yucatan to Texas. Terán's only concession to the Anglo settlers was that "the industry in this colony is outstanding." As is still true today, Terán failed to see the connection between a free person and his or her productivity. His influence on Mexican policy toward Texas ended when he committed suicide in 1832.

Juan Nepomuceno Almonte was the son of a Catholic priest, Jose Maria Morelo, one of the heroes of Mexico's 1810 independence revolt against Spain. Juan Almonte was named after his Indian mother but was acknowledged and mentored by his father. The young Almonte fought alongside his father in revolutionary battles in Mexico, and in 1814, he was named a brigadier general at the age of eleven by his father. In 1815, Almonte was sent to New Orleans to be educated. In that same year, his father was captured, declared a heretic and then executed for treason. Almonte returned to Mexico in 1821, fluent in English, and joined the new Mexican government. He spent the rest of his life in Mexican politics, moving back and forth between the major players.

In 1832, Santa Anna came to the presidency. In 1834, Stephen F. Austin was arrested and imprisoned in Mexico City for a year and a half. In that year, Almonte was sent on a fact-finding mission to Texas much like Terán's. His recommendations were very similar: crush the rebellious spirit of the Americans and allow only immigrants from Mexico and Europe, like the Irish. Austin had tried to be a good Mexican citizen, but he emerged in 1835 radicalized by his imprisonment. The middle ground in Texas between good citizenship and revolt had disappeared.

Almonte was a commander in Santa Anna's army when it entered Texas in 1836. Almonte participated in the attack on the Alamo and served as Santa Anna's translator and chief advisor. Almonte is credited with securing the release of Susanna Dickinson and her daughter, Angelina, after the fall of the Alamo. Susanna was young and beautiful, and Almonte successfully persuaded Santa Anna not to make her one of his mistresses.

Almonte was captured at San Jacinto and served as Santa Anna's translator during the whole of the latter's captivity. He remained a steadfast apologist for Santa Anna's actions at San Jacinto and failed to see any responsibility on Mexico's part for the loss of Texas.

Stephen F. Austin's Militia Was Not a Killing Machine

Stephen F. Austin's colony in central Texas, established in 1822, enjoyed a short period of goodwill from the Indians but ultimately was saved by its militia. When the goodwill from the Indians ran out in 1823, Austin found it necessary to form a militia from his colonists to protect from Indian attacks. This was done with the approval of the Mexican government in Bexar. The Mexican government nominally should have provided security for the colony, but this was just after Mexico's long war of independence from Spain, from 1810 to 1821. Mexico was in shambles and had only about 250 troops in all of Texas. So Austin's colony was on its own, and its survival in the first several years was precarious. Austin's colony was saved by its own motivated militia and its leadership.

Austin's colony included the Colorado and the Brazos Rivers and extended from the Lavaca River on the west to past the San Jacinto River on the east and down to the Gulf Coast on the south. His colony contained or impinged on the territories of at least four Indian tribes—the Tonkawa, the Waco, the Tawakoni and the Karankawa—and was in the raiding path of the Comanche. Of the resident Indian groups, the Karankawa were the most hostile and implacable. For the first year or so, there were no clashes. But in late 1822, two settlers were killed and two severely wounded by Karankawa arrows on the Colorado River near Skull Creek in Colorado County. In the first action by the colonial militia, Robert Kuykendall organized a group of about twenty settlers and attacked a Karankawa camp on Skull Creek. Fourteen of the Indians were killed and seven wounded, with the settlers suffering no casualties.

The settlers were basically farmers with no military experience, and not everyone owned a gun. They had not come to Texas expecting to have to fight, and they served only reluctantly in the militia and for short campaigns. In this, the early militia acted more like a posse. The men were usually mounted on their farm horses or mules but fought from the ground since they were not horsemen. In the early years of Austin's colony, their numbers were meager, and they avoided confrontation in favor of treaty with the Indians.

In September 1823, a group of Tonkawa stole some valuable breeding horses and looted a number of outlying homes in the colony. A militia group of thirty men led personally by Austin visited the Tonkawa camp

and recovered the horses. The Tonkawa had some two hundred to three hundred warriors in camp, but no fight occurred and a treaty was reached. No such accommodation could be achieved with the fierce Karankawa. In the summer of 1824, several new families were killed near the mouth of the Brazos River. In September, a militia company of twenty-three men encountered a larger band of Karankawa and in the battle lost three men to the Karankawa's fifteen. One month later, Austin led a militia group chasing a group of Karankawa west to the La Bahia Mission. At the request of the missionary friar, Austin spared the Indians on their promise to stay west of the San Antonio River. The Karankawa honored this pledge for a year or so.

By 1826, there were 1,600 people in Austin's colony. Manpower was not the problem—guns were. The total strength of the militia reached 565 men, but there were only 345 weapons (muskets plus pistols). So the militia lacked 220 weapons for each person to be armed. Still, 1826 was an active year for battles between the militia and the Tonkawa and Karankawa. By the end of the year, the increasing strength of the militia and Austin's successful strategy for dealing with the Indians had overcome the immediate threat of extinction for the colony. The colony's militia was no killing machine, with inexperienced members and insufficient armament, but under Austin's leadership, it made the difference for the survival of the colony.

FIRST-PERSON ACCOUNT OF ARRIVING AT EL COPANO IN 1834

The following is a realistic but fictional account of the experience of the Irish immigrants arriving at Copano Landing in the 1830s.

I gazed fearfully at the bleak coastline, along with the other passengers at the starboard rail of the wave-tossed schooner, *Sea Lion*. In the dusk, all we could see was a continuous crash of waves along the beach. We knew that the most dangerous part of our journey lay right ahead of us. Not the long, tedious passage from Ireland, where seasickness was the main hazard. Overcrowded for forty days at sea, we were about to leave the open sea for the safety of the bay at Copano Landing. First, we had to get over the shallow sandbar at the mouth of the Aransas Pass and then thread our way along the narrow and shifting channel to Aransas Bay and then through the shell reefs of

Copano Bay. We were anxious to start our new life on our own land in 1834 Mexican Texas, but we knew that we risked going aground, capsizing, drowning or losing all our essential cargo. The captain wisely anchored to wait for daylight.

The captain and crew were up at daybreak, readying the ship's rowboat to take soundings of the water depth at the Pass and to locate the channel beyond. The captain explained all this to my Pa and the other men. My Pa said, "Michael, go get your mother. I want her up here with us." Even if there were eight feet of water at the Pass, we still had to wait until the tide was coming in. That way, if the ship went aground, the rising tide might refloat her. Amanda left her parents' side and came up beside me. "Michael, are you scared?" I nodded, "I guess so. Everybody else seems to be scared, even the crew."

Finally, about two o'clock in the afternoon, the ship weighed anchor and began to approach the breakers. The rowboat marked the channel on the other side of the bar. Everybody was on deck at the rails except those afraid to watch. Those at the rail were clutching it with whitened knuckles. One of the crew was in the bow with a lead-weighted line, chanting his soundings of the depth in fathoms. "By the deep six, now five, now three." The ship's progress was slow but resolutely aimed at the rowboat. Fortunately, the fall weather was sunny and bright, with light clouds and a steady onshore breeze. As we passed over the bar, I looked down. The water was clear enough to see the sandy bottom, and the ship moved into the channel and slowed to follow the guide rowboat. The anxiety that had lifted when we passed through the waves at the bar returned when I saw how treacherous the narrow channel was.

We were surrounded by ankle-deep water and flat, sandy islands on all sides. The channel was just a faintly darker thread of water, which the ship followed, having picked up the rowboat. After a mile, the channel broadened into a bay, Aransas Bay. The water was still shallow, only nine to ten feet deep. After an hour of slow sailing, we came to the mouth of Copano Bay. Low, bent trees could be seen on the shores of the bay, but no sign of life. The rowboat went out again to explore the oyster reefs at the entrance. There they found no deeper water channel in Copano Bay, just a bare path through the reefs.

At least we were in sight of Copano Landing. By then, it was late in the afternoon, so we anchored to make the final passage on the next high tide. In the dying light, I glimpsed a lone naked figure standing on a point of the shore. Before I could say, "Amanda, do you see that?" he was gone. That night, we

listened to all the strange sounds carried over the water from the shore. "Wild animals," someone said; "savages," said another. 'Til then, Indians had been just a rumor. Pa mused, "No one said anything about savages."

Early the next morning, the rowboat went out to pick a path through the reefs. The captain took the ship carefully on a snake-like trail, and we arrived at what was said to be Copano Landing. What we saw was a single, small brush hut on a bluff above a broken-shell beach. About a thousand feet from the shore, we had to drop anchor; the green water was getting too shallow. From here, people and baggage would have to be ferried to the shore in the rowboat or rafts that we would build. Two Mexican soldiers eyed us from the shore but did not offer any sign of welcome or help. I thought, "This new life is going to be a lot of work, and maybe dangerous."

THE FLOOD OF ANGLO-EUROPEAN IMMIGRANTS INTO TEXAS

The flood of Anglo-European immigrants into Texas started in the 1820s, but the initial surge lasted only nine years. In 1824, after Mexico had won its war of independence from Spain, the central government in Mexico City liberalized the laws on foreign immigration (for a while). This resulted in a rush of land grants to empresarios in the mid- to late 1820s and a tide of immigrants from the United States and Europe, lured by the promise of free land.

Stephen F. Austin established the first colony in 1824 at San Felipe on the banks of the Brazos River, at the site of a ferry, ten miles east of present-day Sealy. Austin's father, Moses, had received the grant in 1821 to settle three hundred families in Texas. The majority of these settlers were from the South, primarily Louisiana, Alabama, Arkansas, Tennessee and Missouri. Among the original immigrants, males outnumbered females ten to one.

Martin de Leon founded the only predominately Hispanic colony in Texas in 1824 near present-day Victoria. In that year, he received permission to settle forty-one Mexican families "of good moral character" at an unspecified point on the lower Guadalupe River. As a prominent Mexican citizen, De Leon was granted wider latitude than that allowed foreign empresarios. Since his grant boundaries were not specified, many boundary disputes resulted with his neighboring empresarios, such as Green DeWitt.

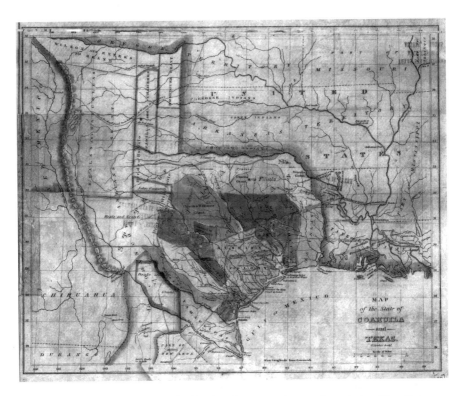

Map of Coaluila and Texas in 1836 showing the *empresario* grant boundaries. *Texas State Library and Archives.*

Green DeWitt received an empresario contract in 1825 to settle "400 industrious Catholic families" in an area that overlapped with the De Leon grant. The initial site surveyed by DeWitt was near Gonzales, but the colony moved in 1826 due to Indian raids. It established a new site called "Old Station" in the prohibited coastal zone near the mouth of the Lavaca River. Thus Matagorda Bay became the port of entry for colonists from the upper South (i.e., Missouri, Tennessee and Kentucky). In 1827, DeWitt was forced by the Mexican authorities to leave Old Station and move with his forty colonists back to Gonzales.

In 1828, empresarios John McMullen and James McGloin received a grant to settle two hundred Irish Catholic families in south Texas. Their first group was recruited from New York Irish neighborhoods. One group landed at El Copano, and another landed at Matagorda by mistake in late 1829. The colonists camped for a while at the abandoned Refugio Mission before moving in 1831 to a site at a ford of the Nueces River, where they established San Patricio de Hibernia.

James Power and James Hewetson received their grant for colonization in 1829, but it was not until 1833 that Power went to Ireland to recruit colonists. The first group of 100 arrived in New Orleans in April 1834, and the remaining 250 arrived about one month later. As many as 150 of these colonists contracted cholera and died, some on the beach at El Copano. The survivors moved to Refugio, where they were joined by an equal number of Mexican colonists recruited in Coahuila.

One of the last of the early immigrant groups to land through El Copano was that of Dr. John Charles Beales and James Grant. They had received a concession to settle eight hundred European families on 3 million acres of land on the upper Nueces River. These immigrants came from Ireland, France and Germany, and the first group of fifty-nine arrived at El Copano in November 1833. They quickly began the arduous task of hacking a wagon road hundreds of miles to their claim. They founded a town called Dolores, unknowingly right on the Comanche raiding trail to Mexico. Dolores was abandoned in 1836 during the Texas Revolution, but many of the immigrants settled in other parts of Texas.

Mexico reversed its liberal policy of foreign immigration in 1830 so that further colonization of Texas had to wait until after the Texas Revolution. However, this early surge of colonists pushed the Anglo-European population to thirty thousand by 1835, outnumbering the Tejanos by two to one. The next wave, of German immigrants through Indianola, started in 1844.

THE DECLARATION OF TEXAS INDEPENDENCE WAS WRITTEN IN ONE DAY

Washington, Texas (Washington-on-the-Brazos), was the site of the Independence Convention in the spring of 1836. Delegates were elected on February 1, 1836, and began to gather at Washington on March 1. Fifty-nine delegates finally attended, as well as a number of supporters and some visitors. There was a sense of excitement and urgency but not calamity, until a rider arrived at the convention with a letter from Colonel William B. Travis. This letter contained the electrifying news that the Mexican army under Santa Anna was in Texas and was besieging Texian forces at the Alamo in Bexar. The Mexican army had been expected, but not for several months. The convention was literally working under the gun.

The delegates met in an unfinished rented clapboard building in Washington, rendered barely habitable by a fierce blue norther. On March 1, a committee was formed to address the first order of business: drafting a Declaration of Independence for the Republic of Texas from Mexico. The convention appointed George Childress as chair. Surprisingly, the committee reported the very next day with a draft of the declaration. It is generally thought that the draft was the sole work of Childress and that he had actually written it on his way to the convention. The Texas Declaration of Independence paralleled the American Declaration in that it started with the principles of government and then went on to list the grievances against the Mexican government ("military despotism…weak, corrupt, tyrannical government") before the final declaration of independence.

The draft declaration was accepted by the convention in a unanimous voice vote on March 2 after a rousing recommendation by Sam Houston. The clerks were directed to prepare a final version for signature by the delegates. In their hurry, the first version was barely readable, so the clerks were sent back to their work. They were also directed to make five additional copies for distribution. After a long, cold night, the clerks completed the six equivalent documents, and the fifty-two delegates present signed all six copies on March 3.

Immediately, express riders were sent with signed copies to five Texas centers: San Antonio de Bexar, Goliad, Brazoria, San Felipe (Austin's colony) and Nacogdoches. The convention also directed that the printer at San Felipe make one thousand handbill copies for wide distribution. One signed copy of the declaration stayed in Washington-on-the-Brazos. Soon after the departure of the express riders, seven additional delegates arrived at the convention and were allowed to sign the declaration, giving fifty-nine signatures on that original copy. Most of the delegates wanted to adjourn on March 3 to go to aid of the Texians in the Alamo, but Houston and others convinced them to stay on to write a constitution. This work they completed quickly, and the convention adjourned on March 17. Much of what is known about the 1836 Texas Independence and Constitutional Convention is due to the detailed diary kept by William Fairfax Gray and published in 1909 under the title *From Virginia to Texas, 1835–1837*.

Thereupon, the delegates left to join the army or their families in the retreat to the east called the "Runaway Scrape." The signed copy of the Declaration of Independence was received in San Felipe by Gail Borden Jr., then the editor of the *Telegraph and Texas Register* newspaper. Borden followed the directions of the convention in part but printed only two hundred copies

Facsimile of the Texas Declaration of Independence signed at Washington-on-the-Brazos on March 3, 1836, showing fifty-nine signatures. *Texas State Library and Archives.*

in handbill form. There is no record of the receipt of the other four signed copies and no evidence that any other copies in handbill form were ever printed at other Texas locations.

It was generally believed that the original copy of the declaration was lost when the Texas state capitol burned in 1881. But then, in 1896, a signed

copy of the Texas Declaration of Independence was found in the office of U.S. Secretary of State Richard Olney in Washington, D.C. It had a written note on the back that it was "the original." It had arrived in Washington on May 28, 1836, by unknown means. It was returned in 1896 to Texas. The "original" in the Texas Archives does indeed contain all fifty-nine signatures. That still leaves the five signed copies with fifty-two signatures missing. Also, there are only five copies of the two hundred printed in handbill form known to exist. Many an attic has been searched in vain for the missing copies of the Texas Declaration of Independence. However, beware the plethora of forgeries that can be found now if you are offered an authentic copy to buy.

THE ARMS AT THE ALAMO WERE BRITISH ON BOTH SIDES

The arms used by both sides at the siege of the Alamo in 1836 were mostly of British manufacture. Contrary to popular depiction, there were probably only a few Kentucky long rifles in the hands of the Texians. The most common gun arming both the Texians and Mexicans was the British East India pattern musket. Mexico had purchased a great number of these muskets in the 1820s as surplus from England and made them the standard weapon for the Mexican army. These were not rifles but rather smoothbore muskets. The Texians captured a store of five hundred of these muskets at the fall of Bexar in December 1835 when General Cos surrendered. In any case, this British army musket had been in America since the early 1700s. It was the main weapon used by both sides in the American Revolution in 1776, although a small number of Kentucky long rifles were also used in that conflict. But the British musket, nicknamed the "Brown Bess," was the weapon used by England in its period of colonial expansion. It was very reliable and easy to load and was used by the British infantry until 1838. Thereafter, the Brown Bess was used around the world into the 1880s.

The Brown Bess musket was heavy at about ten pounds and could be fitted with a seventeen-inch bayonet, which added another couple of pounds. The Brown Bess was made in a number of standard patterns, with a barrel length from thirty-nine to forty-six inches. These smoothbore muskets used a round lead ball of .75 caliber, but they could also be loaded with .35-caliber balls and used like a shotgun. The Brown Bess was fairly accurate out to one

hundred yards and could be quickly reloaded to fire at the rate of four shots per minute. Reloading involved the soldier tearing open a paper cartridge with his teeth and putting some gunpowder in the priming pan. The rest of the powder was poured down the gun barrel, and the empty paper cartridge was dropped in as well. The ball, paper cartridge and powder were tamped with a ramrod, and the trigger ignited the shot with a flint-on-steel spark in the priming pan.

The Kentucky long rifle was more accurate but was slower to load, producing only about one shot per minute. They were also of smaller bore, usually about .36 to .45 caliber, and were all handmade. Since there was no standard bore size, the rifleman had to carry his own lead balls. These characteristics were not a problem in their early use since they were developed for hunting deer in the woods of the Northeast. The long rifle had an effective range out to three hundred yards. But with a barrel length of forty-eight inches or more, the long rifle was rather cumbersome for the western frontier.

The long rifle was developed in America in the early 1700s by German immigrants in Pennsylvania and was initially called the Pennsylvania rifle. The German immigrants were familiar with the rifling process used for the German Jaeger rifle, but the long barrel was an American adaptation. Davy Crockett was one of the Alamo defenders who knew how to use the long rifle effectively. They were especially useful at picking off officers, scouts and artillery gun crews at long distances. This would have had a great demoralizing effect on the attackers, but its slower rate of fire would have been a disadvantage against charging attackers.

Besides the Brown Bess and the Kentucky long rifle, the Texian defenders at the Alamo would have brought whatever arms they had at hand. This would have included double-barrel shotguns and other fowling pieces, as well as an assortment of smoothbore pistols. The Texians would also have armed themselves for hand-to-hand fighting with Bowie and other long knives and tomahawks. The Texians were more adept at individual combat, while the Mexican infantry had been trained in Napoleon-era mass tactics. This advantage in hand-to-hand fighting produced high Mexican casualties at the Alamo and was decisive at San Jacinto, resulting in the name "devil Texians."

THE CHASE TO CAPTURE SANTA ANNA AT SAN JACINTO

The Battle of San Jacinto lasted all of eighteen minutes, but Santa Anna was already running after the first few minutes. The Texian chase after him started at the same instant, and his capture eighteen hours later completed the victory at San Jacinto. Santa Anna had been trying to reach the main Mexican force under General Vicente Filisola that was camped at Fort Bend on the Brazos River, near present-day Richmond. Filisola's forces numbered 1,400, with an additional 1,200 under General Urrea nearby in Brazoria County. Had Santa Anna reached Filisola, the victory at San Jacinto would have become meaningless because the Texian army was not prepared to attack the larger Mexican forces. The Texians were

Military portrait of Santa Anna. *Wikimedia Commons.*

also encumbered with more than 600 Mexican prisoners from San Jacinto. Santa Anna's capture closed off that option, and the subsequent retirement of the Mexican army below the Rio Grande secured independence for Texas.

The chase to capture Santa Anna was thrilling, combining aggressive reaction on the part of the Texians and good strategy on the part of Sam Houston. The strategy involved the burning of Vince's bridge. Both the Mexican and Texian forces had passed over Vince's bridge to get to San Jacinto. And so did a force of five hundred Mexican troops under General Martin Perfecto de Cos, who reinforced Santa Anna at San Jacinto early on the day of the battle, April 21, 1836. After the arrival of Cos, Houston sent Erasmus "Deaf" Smith to destroy the bridge so that both Texian and Mexican forces would face off in a watery dead-end.

The Texians attacked at about four o'clock on April 21, and in the first minutes, Santa Anna fled the battle with a cavalry force of sixty,

accompanied by his personal secretary, Ramon Caro, and General Cos. A Texian cavalry force of eighteen under Captain Henry Karnes saw this escape and broke away from the battle to pursue the Mexican cavalry, saying, "All you with loaded guns, follow me." The Mexicans were headed for Vince's bridge, some ten miles distant over the boggy prairie. The deep mud slowed and tired the horses, allowing the Texians to overtake and kill the rearmost Mexican cavalry, even those pleading "Me no Alamo, Me no Alamo." When the vanguard of Mexicans reached the bridge, they were shocked to find it burned and impassible. They scattered. Vince's Bayou was about thirty feet wide, but it was deep from spring rains and had steep, muddy banks. With the Texians close on their heels, the Mexicans jumped from their horses and tried to swim across. The Texians caught them in the water or struggling up the opposite bank. The waters in the bayou ran red. A few Mexican soldiers made it across the bayou and even made it to Filisola's camp on foot by April 25 to give Filisola his first news of the disaster at San Jacinto. Filisola was already retreating when Santa Anna's orders reached him on April 27.

Santa Anna, Ramon Caro and General Cos abandoned their horses on the banks of the bayou and hid in a grove of trees, waiting for darkness. The Texians hunted until nightfall and then set up a thin picket line with their few numbers. During the night, Caro and Cos swam across the bayou and started for the Brazos River and Filisola's camp on foot. Santa Anna did not attempt to cross Vince's Bayou. He was reputed to have been a nonswimmer and deathly afraid of deep water.

Early the next morning, the Texians resumed their search for Santa Anna at Vince's Bayou under Houston's orders not to harm him. They saw the tracks from the fugitives on the far (western) bank of the bayou, so a party of Texians crossed to pursue them. This party captured Caro and Cos about ten miles along the trail to Filisola's camp, but Santa Anna remained elusive. Another squad under Sergeant James A. Sylvester started back to the Texian camp at San Jacinto. Sylvester spied a lone man walking away from Vince's bridge who immediately tried to hide in the very tall grass. When Sylvester reached him, he did not look like a general. Rather, he had on the coat, pants and shoes of a private. However, upon closer scrutiny, his silk shirt gave him away. Then he asked to be taken to General Houston, where his soldiers greeted him as "El Presidente."

The reports that Filisola received from the first few survivors of San Jacinto were fragmentary and exaggerated. None knew the fate of Santa Anna. Most wildly overestimated the size of the Texian army at up to 4,000 versus

the actual number of 930. But the Mexican soldiers did not exaggerate the ferocity of the "devil Texians." The Mexican generals may not have believed the numbers or the actions of the Texians, but the rank and file Mexican soldiers did. They probably welcomed the decision to retreat.

THE TEXAS REVOLUTION: THE MEXICAN SIDE, IN THEIR OWN WORDS

The loss of Texas in April 1836 provoked anger and anguish in Mexico that fueled decades of debate, written recriminations and self-justifications. Heated treatises were written between 1836 and 1838 by five of the principal Mexican players: Santa Anna; his secretary, Ramon Caro; his second-in-command, General Vicente Filisola; General Jose de Urrea; and General Jose Maria Tornel, the secretary of war during the Texas Revolution. These five documents were translated by Texas historian Carlos Casteneda in 1928 and published as *The Mexican Side of the Texas Revolution*. In the foreword, Casteneda noted that "the documents…show that the traditional sins of Mexico, dissension and personal envy, were more deadly to the Mexican army than the Texan bullets." That set the tone for self-justification on the Mexican side.

The first of these documents was written by General Vicente Filisola in August 1836. As the second-in-command to Santa Anna, he was vehemently reviled in Mexico for following the orders issued by the captured Santa Anna to retire with the army to the Rio Grande. He was formally charged by the army with cowardice and treason but was exonerated in a court-martial in 1841. Filisola's justification for the initial retreat was because the various units of the army were widely dispersed and in need of provisions. Filisola said that he signed the Treaty of Velasco to save the life of Santa Anna and the six hundred Mexican prisoners taken at San Jacinto. He said that he hoped for an exchange of prisoners with the Texans: "Does the law of nations and…our civilization accept war without quarter." But he disregarded that no quarter was given the Texans at the Alamo and Goliad.

Santa Anna wrote his justification in May 1837. He blamed his defeat at San Jacinto on the "excessive number of raw recruits in the five hundred men under General Cos" and added, "The catastrophe at San Jacinto was caused purely by the faults and carelessness of my subordinates and the

disregard of orders…None of these causes was the result of neglect on my part or of acts immediately emanating from me…It was fate and fate alone that clipped the wings of victory that was about to crown our efforts."

Ramon Caro was Santa Anna's secretary throughout the Texas campaign but refuted all of Santa Anna's claims. Caro wrote in August 1837 that Santa Anna's justification was "in keeping with his well known character of duplicity." Santa Anna "comes before the nation to deceive her as he has always done. He has but recently betrayed her anew."

General Tornel in 1837 apparently accepted Santa Anna's excuses at face value: "Fortune forsook him, alas…It was this same fickle goddess that turned her face from us at the very moment when the republic was to gain immense renown…A whim of fate was sufficient for victory…by our spiritless adversaries [the Texans]."

General Urrea disagreed with General Filisola's decision to retreat while still in Texas and immediately attacked Filisola in a confidential report in May 1836. His written treatise was completed in 1838 and continued his attack on Filisola while also trying to justify his massacre of Fannin, King and their men at Goliad.

Each of these documents was wordy, from forty-six to ninety-six pages in translation. Each one was self-serving to the author, except possibly the one by Ramon Caro, Santa Anna's secretary. In the end, no one accepted responsibility for the loss of Texas.

LUCK AT THE BATTLE OF SAN JACINTO

Were the Texians simply "lucky" to win the Battle of San Jacinto? Most of the Mexicans certainly thought so. Santa Anna said as much in his report of May 1837: "It was fate and fate alone that clipped the wings of victory…" The Mexican secretary of war, General Tornel, echoed the same sentiment later that year. However, most people, including many Mexicans, took these statements as a self-serving denial of responsibility for Santa Anna, pointing out the many strategic and tactical mistakes he made. The Texan and American view was that goodness, justice and courage were the basis for victory at San Jacinto. This could also be viewed as a form of fate or destiny, like "Manifest Destiny." No one at the time, least of all the Texian army, thought that it was the result of superior generalship by Sam Houston.

One huge strategic mistake was that Santa Anna, the president of Mexico, was also the general of its army in Texas. This allowed him not only to be defeated at San Jacinto but also to be captured. One can argue that the military defeat at San Jacinto was not fatal to the Mexican cause, but the capture of the Mexican president and his willingness to sign a peace treaty were. General Sam Houston was very astute in the way he handled the aftermath of San Jacinto.

Santa Anna arrived at San Jacinto on April 20 after chasing the Texian revolutionary government, just missing it at Harrisburg and New Washington. Sam Houston and his forces had arrived a few hours earlier, knowing Santa Anna's plans to cross the San Jacinto River at Lynch's ferry from a captured courier. Santa Anna had raced ahead of his main forces with eight hundred of his most elite troops. So it looked like good fortune when General Cos and five hundred infantry joined him at San Jacinto on the morning of April 21, after a forced march. This made the Mexican force superior in number to the Texian army.

Houston consulted with his officers on the morning of April 21, with no clear consensus between attacking and defending their position. But the Texians were spoiling for a fight to avenge the Alamo and the massacre at Goliad. The Mexican troops were resting, planning to attack the next morning. Then Houston and his officers decided to attack at about 4:00 p.m. The Texians attacked in a long line, with Sidney Sherman on the Texian left, where they encountered General Cos's men on the Mexican right. The Mexicans were asleep or resting after their tiring march to reach San Jacinto, so they fell back immediately, starting the rout. As it turned out, Cos's late arrival had not been lucky at all, for his troops were exhausted. It could have been a different battle if the Texians had waited until the next day.

The very wet spring in 1836 had hampered the movements of both armies because of muddy roads and swollen rivers. San Jacinto was described by the Texians as being so wet that horses were knee deep in mud. After San Jacinto, General Filisola decided to fall back and consolidate the remaining four thousand Mexican troops. Despite Santa Anna's orders, there was no immediate consensus to retreat to Mexico. The Texian army was still stuck at San Jacinto with Santa Anna and six hundred Mexican prisoners.

On April 26, Filisola and his troops began moving west from the area of Fort Bend, present-day Richmond. At about noon that day, a heavy rain began to fall, and as the Mexican army was trying to cross the San Bernard River, the rain became a deluge. The river turned into a torrent and the surrounding land a lake. Over this, the Mexican army was trying to move

men, cannons, wagons, cattle and camp followers. The rains continued into April 29, and the Mexican army became mired between the three branches of the San Bernard River. When it emerged from this "sea of mud," as described by Filisola, the Mexican army had abandoned most of its equipment and supplies and was no longer a viable fighting force. Filisola continued the march to Mexico on half rations.

The Texians were lucky that they attacked on April 21, that they captured Santa Anna and that the rest of the Mexican army was caught in a deluge. The Texians' courage, determination and ferocity at San Jacinto carried them the rest of the way to victory and independence.

PORTRAITS OF THE INDIANS OF TEXAS IN 1830

The Frenchman Jean Louis Berlandier, at the age of twenty-three, conducted the first systematic study of the Indians in Texas. In 1828, he was the resident biologist and anthropologist in a boundary expedition to far east Texas. This expedition, headed by General Manuel de Mier y Terán, left Mexico City in November 1827 and in two years made the round trip to Nacogdoches. Berlandier collected botanical samples, discovered many Texas plants and animals and described more than forty Texas Indian tribes. Berlandier was an expert sketch artist, but he was aided by Lino Sanchez in making the first color paintings of Texas Indians from life.

Berlandier had been sent on a mission to Mexico and Texas from the Academy of Natural Sciences in Geneva, Switzerland, arriving in Tampico in December 1826. The Terán expedition was well staffed with military men, scientists and an artist. There was an instrument wagon laden with thermometers, barometers, telescopes, compasses, a sextant and a chronometer. Terán traveled in style in a huge coach of carved wood inlaid with silver. They traveled at a leisurely pace since the wagons and coach were subject to frequent breakdowns. They must have made quite a spectacle to the settlers and Indians in Texas in 1827.

The expedition made its first stop in Laredo, a town of 2,000 people, with a presidio and a garrison of 100. Here, Berlandier had his first view of Texas Indians when a large party of Lipan Apache paid a friendly visit to Laredo. Berlandier and Sanchez began their first sketches of the many Indians they would encounter. Ten days of arduous travel on the Old Bexar

Road brought them to San Antonio, where they stayed for six weeks. The "capital" of Texas had fewer than 1,500 inhabitants at the time but received friendly trading visits from Comanche who lived in the vicinity. Berlandier and Sanchez sketched the Mission of San Antonio de Valero, later called the Alamo.

On April 27, 1828, the expedition reached San Felipe de Austin, the "capital" of Stephen F. Austin's colony, a sprawl of about forty or so "dogtrot" log cabins on the west bank of the Brazos River. General Terán and Austin got along very well, with Austin sharing his hard-won knowledge of the geography and Indians of Texas. Then, on the road to Nacogdoches, the going got a lot rougher: heavy rains, boggy roads, summer heat and clouds of mosquitoes. Berlandier came down with malaria, and he, along with the instrument wagon and coach, was sent back to San Antonio. After recuperating, Berlandier was allowed to roam around central Texas, even accompanying a Comanche party on a buffalo hunt. He visited Goliad and boarded a ship in Aransas Bay for a quick round trip to New Orleans. Throughout his travels, Berlandier continued to document the Indians and collect samples of plants and animals. His industry was prodigious; he collected samples at the rate of 1,400 per month over three years.

The paintings of the Indians made by Sanchez from life are disappointing; they seem too idealized. The reason had to do with Sanchez's training as an artist. He was trained to depict costumes, not people. So the Indians were posed like mannequins to display their dress, and the paintings look like European fashion plates, certainly noticeable in his portrait of a Karankawa couple. As a result, there is very little ethnological information in Sanchez's portraits of the Texas Indians in 1830. What a wasted opportunity.

Berlandier returned to Matamoras in 1830, became a physician and married a Mexican woman. He died in 1851 at the age of forty-six, drowning while attempting to cross a river. Two years later, an American, Lieutenant Darius Crouch, bought Berlandier's entire collection of maps, journals and scientific specimens from his widow for $500. The collection is now spread between the Smithsonian, the Library of Congress and several universities. The translated journals and the color plates of the Indians were published by the Smithsonian in 1969 in the book, *The Indians of Texas in 1830*.

There are many Texas plant and animal species named after Berlandier, the wildflower *Anemone berlandi* being one. He was loved and respected in his adopted Mexican homeland, "universally beloved for his kind, amiable manners and regard for the sick poor of the city," wrote Crouch.

DID AUSTIN COLONISTS EXTERMINATE THE KARANKAWA?

The Karankawa disappeared from Texas in 1852, the remnants of the tribe migrating to Mexico. Some modern authors have asserted that the Karankawa were "exterminated" by Stephen F. Austin and his colonists, like an "ethnic cleansing." The demise of the Karankawa was more complicated, but the Austin colony did play a part.

Robert Ricklis estimated that all the Karankawa bands numbered about eight thousand in 1685, spread out over a littoral territory from Galveston to Baffin Bays. In the year 1685, the Karankawa encountered the first European colonists at the La Salle settlement on Matagorda Bay. The first outbreak of European epidemic diseases, such as smallpox and measles, occurred at Fort St. Louis in 1688. Ricklis also listed at least ten more episodes of European epidemics along the Gulf Coast between 1691 and 1820, the last an epidemic of smallpox at the Refugio Mission. Over this period, the Karankawa population dropped from eight thousand down to about eight hundred. A 90 percent mortality rate for all American Indians was mostly due to epidemic diseases. Jean Lafitte's pirates killed about half of three hundred Karankawa warriors at Galveston in a battle in 1819, a loss from which they never recovered. Austin started his colony at San Felipe in 1823.

Although the Karankawa population was greatly depleted, Austin found them to be intractable, implacable and aggressive. The Austin colony was not really in the Karankawa coastal territory, but arrivals of settlers and food at Matagorda had to pass through their lands. Austin met with a Karankawa group, a band of Coco, in 1821. It was a friendly enough meeting, but the Spanish had already warned Austin that the Karankawa were treacherous cannibals. The bad Spanish opinion was based on their unsuccessful one-hundred-year effort to Christianize and civilize the Karankawa at three coastal missions: La Bahia, Rosario and Refugio. The intransigence and savagery of the Karankawa led some Spanish officials to talk of their extermination as early as 1780. However, the Spanish Franciscan missionaries did not give up on the Karankawa; the last mission, at Refugio, was established in 1795.

Influenced by the Spanish and his own colony's bad experiences, Austin mused in his journal, "These Indians and the Karanquas [*sic*] may be called universal enemies of man...there will be no way of subduing but extermination." Austin was willing to coexist with the Indian bands around his colony and made treaties with the Tonkawa, Waco and Tawakoni. In

1824, Austin met and made a peace treaty with Antonito, a Karankawa chief. But the warriors in Antonito's band continued to attack and kill any vulnerable individual settler or even small parties. Later, in 1824, Austin and his militia pursued a group of Karankawa as far as the mission in La Bahia. Austin accepted the Indians' pledge to remain west of the San Antonio River, a pledge they honored for about a year before moving back. The Karankawa in another band, whose chief was Prudentio, remained at peace with Austin's colonists. Austin preferred peace to war, so he made another treaty with Antonito in 1827, with the same outcome. However, there seemed to be no large battles until that at Hynes Bay in 1852. The Karankawa were active as scouts for Mexican forces in the Battle of Refugio in 1836 but changed sides in the Texas Revolution after the Mexicans executed a chief's son.

After 1836, the Republic of Texas allowed many new settlements in the traditional Karankawa camping areas along the Gulf Coast: Aransas City, Lamar, Indianola, Lavaca and Galveston. The dislocations and conflicts intensified. By the 1840s, the population of the Karankawa had dropped below the level for biological viability. Only about sixty Karankawa men, women and children survived the 1852 battle at Hynes Bay in Refugio County. They were forced to move to northern Mexico. The Karankawa name was heard no more in the Coastal Bend, their passing not mourned until later generations.

The Karankawa character gave them few allies but many enemies. Only a few Texas settlers, like Alice Oliver, ever got to see their human side or began to know them. However, their belligerence and refusal to accept change in their way of life figured in their fate. There is no record of any Karankawa entering Anglo society. While Austin and his colonists did not mourn the passing of the Karankawa, they came on the scene too late and too briefly to have much influence on the final extinction of the Karankawa.

Part IV

THE REPUBLIC OF TEXAS, 1836–1845

IS TEXAS THE ONLY LONE STAR STATE?

Texas is the Lone Star State, right? Then why does the flag of Chile, which is older, look so much like the flag of Texas? Recently, viewing the visiting tall ships berthed in Ingleside, I looked at the ship from Chile and asked, "Why is it flying the flag of Texas?" But something about it did not seem quite right. What was the difference?

The national flag of Chile was adopted in 1817 after Chile won its independence from Spain. It has the equal-size horizontal red and white bars like the flag of Texas, except that the lower red bar extends all the way across the bottom. On the Texas flag, the lower red bar extends only to the vertical blue bar. The flag of Chile has a square of blue, called the canton, in the upper-left corner containing the lone white star. The Texas flag has the white star in the middle of the blue vertical bar. Amazing coincidence, or who influenced whom? Turns out that there were a number of Americans involved in the Chilean revolt.

David G. Burnet, who became the first interim president of the Republic of Texas, was in South America in 1806 fighting with the revolutionaries. Joel Robert Poinsett was sent to South America by President James Madison as an agent of the United States. Poinsett and the United States had a very positive influence on the new revolutionary government of Chile and may have had a part in its new national flag. From a distance at sea, the Chilean

The Texas Lone Star flag, adopted in 1839. *Wikimedia Commons.*

The national flag of Chile, adopted in 1817. *Sebastian Koppehel and Wikimedia Commons.*

flag could be mistaken for the American flag, a disadvantageous mistake if made by pirates.

The Republic of Texas had a number of flags on its path to independence. One of the earliest was the flag of the short-lived Republic of Fredonia in 1824. This flag consisted of only two equal red and white horizontal bars, with no star. However, the filibuster or freebooter James Long, had the first Lone Star flag on record in 1819. One version of this was designed by his wife, Jane Long, who is called the "Mother of Texas." This flag had a single white star in the middle of a solid red background. It may have flown at Washington-on-the-Brazos when independence was declared in March 1836. During the fighting, other flags were used that did not involve the lone star, such as the cannon in the "Come and Take It" flag used at the Battle of Gonzales in October 1835. Other revolutionary flags showed a single blue star against a solid white background or the reverse.

One thing is clear: the newly born Republic of Texas did not have a universally accepted Lone Star flag. However, the navy of the Republic of Texas needed and got a flag. Samuel May Williams and Thomas F. McKinney loaned the new republic $100,000 to buy ships for the Texas navy in 1836, and the ships needed a flag. Williams had been in South America from 1814 to 1818, and he proposed (and President Burnet approved) a flag very similar to the flag of Chile, with a lone star in the canton, except that it had thirteen red and white horizontal stripes, like the original American flag—again, very easy to confuse with the U.S. flag at sea.

This situation persisted until 1838, when William H. Wharton headed a committee to design a national flag for the Republic of Texas. In 1839, Dr. Charles Bellinger Stewart came up with a freehand drawing of the final design of the Lone Star flag that we have today. His original is in the Sam Houston Library of the Texas State Archives. His original design was not even colored; the colors were simply written on the drawing. The Stewart design was accepted by President Mirabeau B. Lamar in 1839. Although Stewart was recognized by the Texas legislature in 1997 as the designer of the Texas Lone Star flag, its long gestation probably reflects contributions by Burnet, Long, Poinsett, Williams, Wharton and others, possibly including a Chilean or two.

The Reluctant Republic of Texas

At its start, in 1836, the Republic of Texas was not meant to last. Most Texans wanted to be swiftly annexed by the United States. But the U.S. president and Congress were embroiled in a fight over the admission of Texas as another "slave" state, so no offer for Texas to join the Union was forthcoming. Soon, there was a sizable faction in Texas that wanted to remain a republic, with designs on an expansion to Mexican California or an alliance with England. The Republic of Texas was also deeply in debt, with no way to raise revenue through taxes.

The Republic of Texas was born too quickly. The original confrontation with Mexico in 1835 was over the restoration of the Mexican Constitution of 1824, which had been abolished by Santa Anna. But by March 1836, the passions of Texans were directed at independence, such that a Texas constitution was adopted by the same convention that declared for independence. Then, six weeks later, the war was over after the victory at San Jacinto.

The first elected Congress of the republic had fourteen senators and twenty-nine representatives and met at Columbia in Brazoria County in September 1836. Among the first acts of this Congress and the new president, Sam Houston, was to petition the United States for recognition and annexation. However, John Quincy Adams denounced the Republic of Texas on the floor of the U.S. House of Representatives for its extension of slavery. Suddenly, annexation of Texas divided the states along the lines of the coming Civil War. However, President Andrew Jackson was able to engineer the recognition of the Republic of Texas on March 3, 1837. It would take two more U.S. presidents and much politicking on both sides before Texas was admitted to the Union in 1845.

The Republic of Texas was land-rich and cash-poor from the start and had a large amount of debt from the revolution. The republic made extravagant boundary claims to the west, based on following the Rio Grande to its headwaters in New Mexico and Colorado and on the Arkansas River rather than the Red River. The republic had forty thousand inhabitants residing on plantations and ranches and in only seventeen settlements, all located on rivers. There was no money economy and no money. Cotton was the only major export, and it was bartered for imported goods. All manufactured items had to be imported, plus foodstuffs such as wheat and coffee. There was no industry, no banks, no schools and no road system.

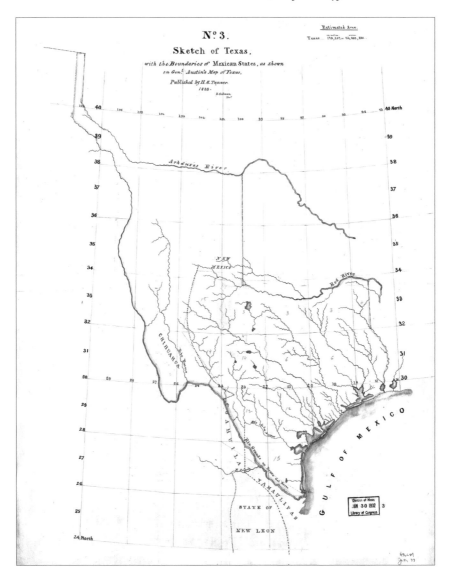

Map of Texas in 1839. *Map by John Arrowsmith. Library of Congress.*

The politics were also deeply divided, with a faction headed by Sam Houston and another following Mirabeau B. Lamar, who succeeded Houston as president of the republic in 1838. Lamar's nationalist faction favored keeping Texas as a republic, negotiating with Mexico, expanding west to California and subduing the Indians, mainly the Comanche, by force. His ambitious programs resonated with the new Texas spirit, but he spent money that Texas did not

have. Houston became president for another three-year term in 1841 but put off solving problems with Mexico and the Comanche in the hopes of rescue as a U.S. state. Texas was invaded twice by Mexican armed forces in 1842; they captured San Antonio before retiring on their own. Houston had furloughed the Texas army, and these invasions were opposed by only a small force of Texas Rangers. Houston's republic had a dim future without U.S. annexation. Lamar's aggressive actions had succeeded in obtaining recognition of the Republic of Texas from Britain, France and Belgium. U.S. politicians began to worry that Texas would strike a strategic alliance with Britain, so the United States began to pursue annexation of Texas in 1843.

By 1845, the United States was anxious to conclude the negotiations with Texas, but now Texas held the advantage. Texas was admitted to statehood on March 1, 1845, as a slave state, while retaining title to its public lands. Texas's boundaries were not settled until 1850. In the Compromise of 1850, Texas gave up its claim to the contested northern territories in exchange for the U.S. assuming Texas's $10 million debt. There were a number of proposals to set the western boundary, but the Pearce line prevailed, giving Texas its now characteristic panhandle profile. The republic was no more.

TEXAS WAS ONCE BORDERED BY TWO LAWLESS STRIPS

Texas once had two lawless strips, or "no man's lands," on its disputed boundaries. They provided havens for outlaws, refugees, rustlers and revolutionaries for years until they were cleared by Texas militia or Rangers. Both strips were engendered by national boundary disputes; one lasted for forty years and the other for fifty. Both rendered their areas hazardously habitable for law-abiding citizens.

The first strip was called the Neutral Ground and originated in the dispute over Texas's eastern border with Louisiana following the Louisiana Purchase. In 1803, President Thomas Jefferson asserted that Texas was part of the Louisiana Territory bought by the United States. Spain disagreed, and the situation along the Texas-Louisiana border seemed headed toward armed conflict. Actually, there were two issues: was Texas part of the Louisiana Purchase and, if not, where was the Texas-Louisiana border? To avert war, General James Wilkinson, the American military commander, met with his Spanish counterpart, Colonel Simon de Herrera, on November 6, 1806, and

the two agreed that the disputed border area would be a Neutral Ground. The area was never specifically defined, but the Arroyo Hondo on the east and the Sabine River on the west served as the approximate boundaries. Both Spanish and American forces and settlers were to be barred from this Neutral Ground until the border issue could be resolved.

This ungoverned area was quickly exploited by lawless elements from both sides. Thieves, murderers, smugglers and revolutionaries found it a perfect haven. The situation deteriorated further in 1810 during Mexico's revolt for independence from Spain. In 1812, Lieutenant Augustus Magee was ordered to go in and clear out the Neutral Ground. However, Magee quickly turned around to lead a force of filibusters to free Texas from Spanish rule. Ownership of the strip went to the United States in the Adams-Onis Treaty in 1821, which established the Sabine River as Texas's eastern boundary.

However, this was not the end of problems with this strip. The Fredonia Rebellion was fomented there in 1825, this time against Mexican rule. The first settlers came to the strip in 1833, and it experienced a land rush during the republic period. But in 1840, the border was again in dispute and caused four years of fighting, the so-called Regulator-Moderator War. Again the Neutral Ground became a haven for the lawless. Finally, in 1844, republic president Sam Houston sent the militia in to quell the fighting and enforce the current boundary along the Sabine River.

The other lawless strip was the Nueces Strip, the area between the Nueces River and the Rio Grande. This strip became a part of the Republic of Texas after the Texas Revolution, but this was actively disputed by Mexico. Santa Anna sent two military expeditions into Texas as far as San Antonio in 1842. After the Mexican-American War in 1846, U.S. and Texas ownership of the strip was settled in the 1848 Treaty of Guadalupe Hidalgo. But the strip was controlled by outlaws and raided by hostile Indians. Law enforcement was not helped by the sporadic existence of the Texas Rangers, pawns of the party in power in the Texas statehouse.

In the 1870s, the ruler of the outlaws in the Nueces Strip was King Fisher. His ranch was a magnet for criminals, rustlers and drifters. He cut a very imposing figure when dressed in an ornamented sombrero, a gold-trimmed black Mexican jacket and a crimson sash, while carrying two ivory-handled pistols. His kingdom was based on cattle rustling in both Texas and Mexico and his dominance of the existing politicians. In 1874, Texas Democrats returned to power, and so did the Texas Rangers. In 1875, a forty-man company of Special Texas Rangers, led by Captain Leander McNelly, moved in to clean up the Nueces Strip. In eight months of hard fighting

and hasty executions, the Rangers restored some degree of order, if not tranquility, to the strip. King Fisher was arrested multiple times but managed to avoid conviction. However, the pressure caused Fisher to "retire," so he moved and married in 1876. He was killed in a shootout in the Vaudeville Variety Theater in San Antonio in 1884.

McNelly retired to a farm in Burton in 1876. Although criticized for extralegal and brutal methods in the 1875–76 campaign in the Nueces Strip, the citizens of south Texas erected a monument to McNelly.

THE OLD SOUTH PLANTATION LIFE IN BRAZORIA COUNTY

Brazoria County has a very distinctive place in Texas history. It was the settlement site for many of the initial colonists in Stephen F. Austin's Old Three Hundred. It supported the first large-scale successful agriculture in early Texas because of its position in the fertile bottomlands between

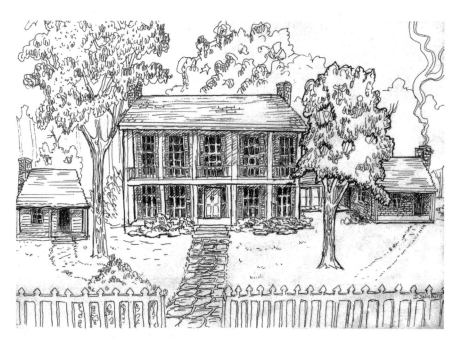

Sketch by J. Salisburg of the Calvit-Herndon plantation in Brazoria County in the 1850s. *Photo by author.*

the Colorado, Brazos and San Bernard Rivers. Columbia was founded on the Brazos River by Josiah Bell in 1826 and became a major port. It was important enough to become the first capital of the Republic of Texas.

Brazoria County was the one place in Texas where the southern plantation way of life was most evident, including the holding of slaves. There were more than sixty plantations in Brazoria County cultivating cotton, corn and sugar. Twenty-three plantations were producers of sugar, which was partly refined on plantation premises. The Imperial Sugar Company was started in 1843 in nearby Sugarland to complete the refining process.

Peach Point Plantation was the home of Stephen F. Austin's married sister, Emily. It was the only place that Austin considered as his home in Texas, and he was buried there upon his death in December 1836. The Calvit-Herndon plantation was built near Columbia by Alexander Calvit, one of the original settlers. John Hunter Herndon married Calvit's daughter and raised Arabian horses there. The Varner-Hogg plantation is a state park now and has been restored to its original condition. It is one of the best sites in Brazoria County to capture the feel of the lifestyle of the Old South in Texas.

COLUMBIA: FIRST CAPITAL OF TEXAS, 1836

Columbia, now called West Columbia, was the first capital of the Republic of Texas, before Houston and Austin. The first elected Congress of the new Republic of Texas was convened in Columbia on October 3, 1836. The provisional government had been forced to move several times to escape Santa Anna and his Mexican army after the declaration of Texas independence at Washington-on-the-Brazos on March 2, 1836. The provisional government had moved to Harrisburg, then Galveston and finally to Velasco. There, the interim governor, David Burnett, called for the election of the first representatives and senators and decreed the first meeting of this Congress in Columbia. Fourteen senators and twenty-nine representatives from twenty-three counties gathered at Columbia on the first Monday in October to conduct business under the new president, Sam Houston.

Columbia was chosen because it had the best facilities left in the republic, but still the functions of the government were spread over nineteen rooms in ten buildings, all hastily and sparsely furnished for the occasion. The House and the Senate met in two separate buildings, one a former residence and the other

a store. The tables were borrowed from local kitchens. Despite the primitive conditions, the first Congress accomplished much: it ratified the constitution, created the judiciary, set up the army, the navy and a postal service, established a land office and the financial system with a network of committees. Santa Anna was also being detained nearby at the plantation Orozimbo.

Columbia was a port on the Brazos River in Brazoria County and the most prosperous area in Austin's colony and the state. The area was also the site of the earliest battles in the war for Texas independence. The population of the area was three thousand in 1836. The port and the town were laid out in 1826 by Josiah Bell, one of Stephen F. Austin's original three hundred colonists. The port was a principle access point to interior Texas, and the Brazos River was navigable by steamer as far north as San Felipe. The town of Columbia was established a few miles away from Bell's Landing, and eventually, two towns coexisted, one on the east and one on west bank of the Brazos. Besides the commerce of the port, there were sixty or more plantations in the rich river bottoms area, growing cotton, corn and sugar. The plantation life resembled that of the old South, with hospitality to visitors practically a religion. During the time when Columbia was the capital of Texas, this hospitality was taxed to the extreme.

Housing was the biggest problem in Columbia in the fall of 1836 due to the influx of all the citizens attracted by the first Congress. Not only were the legislators and the cabinet there, but also members of the Texian army and navy were present, seeking back pay and land grants, as well as various other hangers-on. The only hotel was beyond capacity, and bed space was at a premium. A bed or bedroll space sold for fifty cents per night, and you had to pay for the whole room if you wanted privacy. Lacking resources, many of the visitors spread out their bedrolls under the large oak trees at night and took their meals at the hotel. It was said that Josiah Bell discouraged the townspeople from providing more spacious accommodations for the congressional influx because it annoyed his free-roaming pigs. On November 30, 1836, the Congress of the Republic met in joint session and voted to move the seat of government to Houston, founded a few months earlier. With this removal, Columbia declined as a commercial center.

The poor accommodations had one other outcome. Stephen F. Austin had been laboring long hours as secretary of state in an unheated shed, often overnighting there. Austin caught a cold that turned into pneumonia and caused his death on December 27, 1836. His body was dispatched from Bell's Landing on the steamship *Yellowstone* for the short trip to Peach Point Plantation, where he was buried.

Aransas City, Lamar and Copano
Competed for Primacy

A number of ports and landings were fighting for primacy in the southern Gulf in the years of the Republic of Texas. The competition centered on two bays: Aransas and Matagorda. Aransas City and Lamar were early southern ports, established well before St. Mary's of Aransas, Indianola, Rockport and Corpus Christi. Land titles were uncertain because the Republic of Texas claimed ownership of all vacant lands. Even former empresarios were required to submit surveys of their original Mexican grants in order to retain title.

In this atmosphere, the former empresario James Power decided in 1837 to establish a port on his land on Live Oak Point at the entrance to Copano Bay. He named this port Aransas City since it was near the site of the old Spanish Fort Aranzazu. Both were built near Live Oak Springs, about four miles north of present-day Fulton. In 1839, the Congress of the Republic of Texas approved the incorporation of Aransas City, with Power as mayor, and also established the customhouse there. Power built a wharf, and the population surged to about ninety-eight families. Power was a business partner with Joseph Smith until the latter managed to litigate away Power's land on Copano Bay, where St. Mary's would be built. The competition with other nearby ports and raids by Comanche and Karankawa caused Aransas City to be abandoned by 1847.

At about the same time (1837) as Power, James Byrne, a Power colonist, established Lamar within sight of Aransas City on the other side of the bay. Byrne named his town for Mirabeau B. Lamar, the president of the Republic of Texas. Byrne built a wharf, and in 1839, he petitioned the republic to move the customhouse to Lamar on the basis that it had a bigger population (it did not). President Lamar ruled in Byrne's favor, but the customhouse was moved back to Aransas City one year later. Lamar prospered until it was destroyed in the Civil War.

Both El Copano and Black Point had served since 1750 as landings on Copano Bay for passengers and goods destined for La Bahia (Goliad) and Bexar (San Antonio). And Copano Landing was the port of entry for the Irish colonists in the early 1830s. Captain Monroe arrived with a load of Irish colonists in 1834 and reported a "small, half-finished frame house" on the Copano bluff. It served as the Mexican customs shack; the customs master lived in La Bahia. Joseph Plummer built the first house in El Copano

in 1840, and James Power moved his home to El Copano in 1850 after Aransas City was abandoned. At its peak, El Copano had about a dozen shell crete buildings, a wharf and the shortest route by ox cart and mule train to La Bahia and San Antonio de Bexar. El Copano prospered until about 1860 but eventually was surpassed by St. Mary's of Aransas, founded in 1857.

St. Mary's of Aransas and Indianola (on Matagorda Bay) were both founded in the mid-1850s and became the dominant southern ports for about thirty years. Most of the long-leaf pine lumber used in south and central Texas came from Florida through St. Mary's. Indianola received a large U.S. Army contract as the port for military supplies for forts in west Texas. Neither was a deep-water port but instead relied on long wharves to reach even eight to ten feet of water. Still, they grew to have populations in the range of four thousand. Both St. Mary's and Indianola were devastated by a series of hurricanes in the 1880s and were abandoned by the early 1890s. They were supplanted in south Texas by Rockport and Corpus Christi.

Galveston rebuilt after the Great Fire of 1885 that consumed half of the town and the hurricane of 1900 to remain the premier port of Texas until it, too, was surpassed by the deep-water channel to Houston.

THE TEXAS RANGERS MEET THE COLT REVOLVER

The frontier war with the Comanche in Texas in the 1840s was definitely going against the Texans. New settlers pushing into the Comancheria in central Texas brought more violent attacks by the Comanche. The Comanche roamed at will across Texas and set the rules of engagement. These rules allowed the Comanche to strike in overwhelming force at the site and time of their choosing and then ride fast and long to escape pursuit and reprisal. No pursuing force had ever ventured very far into the Comanche homeland. This is how the Comanche had become the dominant military power in the western plains in the era of Spanish and Mexican governance. But the Texans brought something new.

To be sure, the Comanche were a formidable force against homesteader Texans fighting on foot. The Comanche were superb horsemen, and their attacks could be launched with lightning speed. They never attacked except when they held the advantage of surprise and numbers. The Comanche

did not like to take casualties. But the speed and stamina of the Comanche mustang meant that they never had to worry about pursuit. Their superiority also extended to weaponry. The Comanche could launch five iron-tipped arrows from horseback in the time it took to reload a musket or rifle, and their buffalo-hide shields could deflect anything but a direct hit. The settlers' and soldiers' muskets were clumsy and had to be loaded and fired from the ground. In the first phase of the Indian wars, the Comanche had little to fear from the Texans.

That changed in the presidency of Mirabeau B. Lamar in 1838. Lamar abandoned the pacifist policies of Sam Houston with regard to the Comanche and authorized the recruitment of eight companies of mounted volunteers. These volunteers were tough, adventure-seeking young men and came to be knows as "Rangers." By lethal lessons, the Rangers learned to fight like the Comanche, and they began to carry the fight into the Comanche homeland. Under their charismatic leader, John Coffee Hays, the Rangers "moved as lightly over the prairie as the Indians did." Since the Apache and the Tonkawa hated the Comanche, they were recruited to serve as trackers and scouts and gladly joined the attacks on the Comanche. Texan attacks on Comanche camps usually achieved surprise because the Comanche thought that no one would dare to come after them.

Still, there was the limitation of the single-shot rifles and pistols of the time. But in 1838, Samuel Colt began to manufacture his patented five-shot revolver in Paterson, New Jersey. The U.S. government was not interested in his revolver, but in 1839, Lamar bought 180 of them for use by the Texas navy. John Hays did not learn of these revolvers until 1843, and he immediately saw the potential to turn the odds in the fight against the Comanche. The Rangers drilled in shooting the revolver at close quarters from horseback.

The first field test of the Colt revolver came at the Battle of Walker Creek in the hill country west of Austin in June 1844. Hays and fifteen men were attacked by a party of seventy-five Comanche. The Comanche taunted the Rangers with the cry of "Charge" in Spanish and English. So Hays charged. The first skirmish lasted fifteen minutes before the Indians broke and ran, and then it became an hour-long running fight over rough ground. When it was over, twenty Comanche were killed and another thirty wounded, to one Ranger dead and three wounded. Part of the success in this battle was due to Hays's great military leadership and part to the increased firepower of the revolver.

The news of this battle and the paradigm-shifting role of the Colt revolver spread quickly over the Texas frontier. However, it would take the

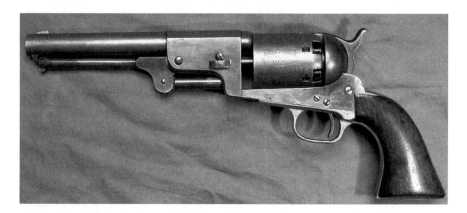

Early Colt revolver. *Wikimedia Commons.*

performance of the Texas Rangers and their revolvers in the Mexican-American War of 1846 to convince the U.S. Army. By that time, Colt had gone into bankruptcy and closed his factory. In 1847, Colt received a contract to make one thousand new revolvers for the U.S. government at a cost of twenty-five dollars each. Colt recruited a Texas Ranger, Samuel Walker, temporarily stationed in Washington, D.C., to help with an improved design. This new design was more rugged, with a longer barrel, and had a six-shot chamber for .44-caliber bullets. Thus was born the Walker Colt six-shooter, the gun that won the West.

COMANCHE, VAQUEROS AND RANGERS IN 1844 RODEO

The first "rodeo" where Comanche, vaqueros and Texas Rangers competed peacefully occurred at San Antonio in 1844. The events were based on fighting and horsemanship skills and bore little relation to modern rodeo events. This was probably also the last such tri-ethnic event, although it would probably have been a good substitute for actual warfare. The rodeo was the idea of Captain John Coffee Hays of the Rangers and happened in the last days of the Republic of Texas, in late 1844. The participants all knew one another well.

Captain Hays and his company of thirty-five Texas Rangers were encamped at San Antonio when a band of Comanche arrived to initiate

peace talks. Hays suggested a friendly contest of skills. Fifty Comanche returned in a few days under a flag of truce, led by the great Comanche leader Buffalo Hump. Captain Hays was known to the Comanche as "Captain Yack" or "Devil Yack" and was respected as a great leader and fighter. Similarly, Buffalo Hump was the leader of the great Comanche raid on Victoria and Linville in 1840. Buffalo Hump must have had a good deal of trust in the word of Captain Hays because San Antonio had been the site of the massacre of Comanche chiefs in the Council House Fight of 1840. The invitation also went out to the San Antonio–area rancheros to send their best vaqueros to the contest. The judges were Buffalo Hump, Captain Hays and one of the rancheros.

This was a huge, festive event for San Antonio, and almost all of the townspeople showed up at the site on a beautiful prairie half a mile west of the town plaza. The arena was laid out some three hundred to four hundred yards long. All contestants were arrayed in their finest garb. For the Rangers, this meant their finest (or only) buckskin hunting shirt, leggings and slouch hats, with revolvers and Bowie knives stuck in their belts, drinking mescal and "scorch gullet" to get into the spirit. The Indians were decked out in "paints, feathers and furs." The vaqueros were in their broad-brim, high-crown sombreros and "slashed" trousers. The event was witnessed by John C. Duval, a survivor of the 1836 Goliad massacre.

The first event involved laying a spear on the ground and challenging the riders to lean down from the saddle and pick it up at a gallop. All of the Rangers, Comanche and caballeros performed this flawlessly. Then a glove was placed on the ground, and again the riders were required to pick it up at full gallop. Again, all succeeded. The next contest was in shooting skill. A bull's eye was painted on a board stuck in the ground. The riders fired from horseback at the target while riding at full speed. According to Duval, none of the Comanche "failed to strike the board with one or two arrows as they went by." The vaqueros and Rangers fired pistols, some hitting the center of the bull's eye.

There were also demonstrations of horsemanship that involved hanging on the horse and firing under the horse's neck. There was even a wild mustang breaking event. The contests were all close; prizes included fancy pistols and Bowie knives. The panel of judges awarded first prize in horsemanship to Ranger John McMullen, second prize to Comanche Long Quiet, third to rancher-trader Henry Kinney and fourth to the ranchero Don Rafael. Hays and Buffalo Hump politely declined to display their own personal skills in the events. Other gifts were offered

to the Comanche, and they departed with goodwill all around. Buffalo Hump continued to try to forge a peace treaty between the Comanche and the republic and, later, the State of Texas.

What this rodeo showed was the parity in skills between the best of the vaqueros, Comanche and Rangers. The Rangers had the fewest years of experience in these survival skills, starting only in the mid-1830s. But the Rangers were the main keepers of the peace in the Republic of Texas, when they were pitted against Indian raiders and Mexican soldiers and bandits, as well as Texan criminals. Their survival skills had been hard won, following Darwin's law of the survival of the fittest and causing the mortality rate among Texas Rangers to approach 50 percent.

JACK HAYS WAS A LEGEND IN HIS OWN TIME

John Coffee "Jack" Hays was truly and deservedly a legend for his time in Texas. He is famous as a leader and keeper of the peace in the Republic of Texas. Hays was born in 1817 in Little Cedar Lick, Tennessee. Working as a surveyor in Mississippi, the nineteen-year-old Hays arrived in Texas just after the Battle of San Jacinto. In 1836, he enlisted as a private in the first ranger company, commanded by Erasmus "Deaf" Smith. A company of twenty Rangers stationed in San Antonio was charged with policing all of Texas's western frontiers. In the turbulent period between 1836 and 1846, Hays rose to captain and then colonel, leading always-outnumbered Rangers against Comanche and invading Mexican troops. He deserved the nicknames given him by his adversaries—"Devil Yack" and "White Devil." The account of a battle at Painted Rock demonstrates his charisma.

In March 1846, Hays and a troop of forty Texas Rangers were tracking a war party of six hundred Comanche that had raided around San Antonio. The Rangers found day-old tracks at Enchanted Rock, near Fredericksburg, and Hays surmised that the Comanche were headed for a lake at Painted Rock. Hays pushed the Rangers to ride day and night to reach Painted Rock by a more direct route to arrive there first. The Rangers succeeded by about six hours and concealed themselves in a willow grove with their backs to the lake. The Comanche sauntered toward the lake, certain that no Rangers were in pursuit. Imagine the surprise of the leading Comanche when they were cut down by rifle fire.

However, the Comanche soon realized that there were not that many Rangers and prepared to attack. The Indians were armed with bows and stone-tipped arrows, fourteen-foot lances and buffalo-hide shields. The Comanche had only a few rifles, but they could loose five arrows per minute accurately while riding at a full gallop. The Rangers were equipped with muzzle-loading rifles and the new Colt five-shot revolver.

The Comanche were led by a war chief, resplendent in a buckskin shirt decorated with long fringes, silver ornaments and topped by a

Photograph of John Coffee Hays, famous Texas Ranger in the Republic of Texas. *Wikimedia Commons.*

buffalo-horn headdress. The first charge of the six hundred screaming warriors must have been very unnerving for the Rangers, one of whom was only sixteen years old, but Hays steadied his men: "Pick a warrior facing you and aim carefully." The Rangers held their fire until the Indian charge was only fifty yards away. Their rifle volley decimated the leading rank of charging Comanche and turned back this attack. The chief rallied his warriors and tried different tactics. One time, he sent four successive waves of attackers so that the Rangers would not have time to reload their rifles. Almost worked. Some of the fourth wave made it into the willow grove, but they were killed by the Colt revolvers. By this time, the Comanche had figured out that they were up against "Devil Yack" and spent time hurling verbal taunts and abuse at him.

On the third day, the Comanche chief led his depleted force against the Rangers once again. His shield had so far protected him from the fusillade of Ranger bullets directed his way. But when he half-turned to urge his warriors on, he briefly exposed his side, and Hays put a bullet into him. When he fell, the charge skidded to a stop, and the remaining Comanche fled the area. The Rangers counted one hundred dead Indians. The Comanche retreat was so headlong that they left behind fifty stolen horses.

This engagement was characteristic of Hays, but it probably never happened. It was not reported at the time even though the size of the engagement would have been very remarkable. The first account of the battle at Painted Rock was published in a 1910 newspaper article. A twenty-year-old eyewitness would have been eighty-four by that time. Texas Ranger historians have not listed the battle either. This shows that when you are a legend, you don't have to make up stories about yourself; others will do it for you.

THE PANIC OF 1837 ALMOST SANK THE REPUBLIC OF TEXAS

The financial Panic of 1837 was a severe blow to the fledgling Republic of Texas. The Panic of 1837 was a monetary crisis for the whole United States, causing a severe five-year depression. There had been a series of "panics" in the United States of varying severity in 1793, 1796, 1819, 1825, 1857, 1873, 1884, 1890, 1893, 1896, 1901, 1907 and 1910, up to the Great Depression of the 1930s. They were caused by inflation, deflation, speculative fever, the banking system and governmental policies. Andrew Jackson's policies were widely blamed for the Panic of 1837, although Martin Van Buren was actually president when it started. Jackson refused to renew the charter of the Second Bank of the United States, causing the withdrawal of all government funds from that bank. On May 10, 1837, every bank in New York City accepted payments only in gold or silver coinage because state banks were thought to be printing excessive paper money. This brought nationwide economic activity to a near standstill.

Almost all states felt the depressive effects of the 1837 panic; 343 of the nation's 850 banks failed, with an aggregated loss of $100 million and a shrinkage of the money supply by 34 percent. The system of state banks received a shock that persisted for decades. Real estate prices collapsed, and so did the price of food. Farmers were ruined because they could not get a high enough price for their crops. This caused food riots and massive unemployment in the industrial East.

Texas suffered because the cotton market collapsed. Although England was anxious to import Texas cotton to supply its burgeoning cotton clothing mills, buyers in London could not receive credit for imports from the United

States. So cotton prices fell. Cotton was the major cash crop in the new Republic of Texas, which had only custom duties as a source of government funds. So the Republic was starved for cash and credit. Texas already had debts from the War for Independence and needed money for a navy and also for a militia to defend against Mexico and Indians. Lacking money, President Sam Houston had disbanded the Texas army and entrusted defense to a small number of Texas Rangers. All this was in addition to the political turmoil involving joining the Union in the face of congressional opposition to slavery.

The Williams family, my ancestors, were very instrumental in getting the Republic through these tough economic times because of their credit connections in the East and their entrepreneurial spirit. Samuel May Williams was the first to come to Texas, arriving in 1822 and serving as Stephen F. Austin's secretary, translator and land commissioner for thirteen years. Eventually, Samuel Williams was joined in Texas by two brothers and an uncle, all from an established mercantile tradition in Rhode Island.

Samuel Williams and Thomas McKinney used their credit in the United States to buy arms and supplies for the Texas Revolution. Williams and McKinney also owned the steamships *Laura* and *Yellowstone*, which plied the waters of the Brazos River to start the export of Texas cotton in 1833. In 1837, Williams used his connections in the East to negotiate a $5 million loan to purchase seven new ships in Baltimore for the Texas navy.

Williams and McKinney were instrumental in developing the wharf facilities in the city of Galveston to serve as the center for the Texas cotton trade. Although state banks were prohibited by the Texas Constitution, Williams received permission in 1841 from the Texas Congress to start a bank and issued $30,000 in paper money as an aid to commerce. The banking activity and wharves of Galveston made it the largest city in Texas by 1840. Galveston was handling more than $1 million a year in trade and became the primary destination for European immigrants. Williams's brothers, Nathaniel and Matthew, developed a sugar plantation in the 1830s that became the Imperial Sugar Company.

Because of the efforts of energetic merchants and entrepreneurs like the Williams, the Republic of Texas was able to survive the Panic of 1837. Texas's debt remained unpaid until after 1845 statehood. In the Compromise of 1850, Texas received $10 million from the federal government in exchange for giving up its extravagant territorial claims in New Mexico and Colorado.

HOUSTON WAS A BOISTEROUS BOOMTOWN EVEN THEN

Houston was the first boomtown in the Republic of Texas, founded when the Republic was only three months old. Houston started in 1836 as a frontier town on the banks of the Buffalo Bayou with a few rude houses and muddy streets. But it was aggressively promoted by two Allen brothers, who had bought the land for the town site in August 1836 for $5,000. They immediately ran an ad in the *Telegraph and Texas Register* touting the "Town of Houston" as the new "commercial emporium" for Texas. And so it became! The first legislature of the republic made Houston the new capitol on November 30, 1836, so the Allens quickly changed their ad to read "the City of Houston and The Present Seat of Government of the Republic of Texas." The Allens declared that "ships from New York and New Orleans could sail up Buffalo Bayou" all the way to Houston. That flight of imagination and hyperbole only became reality when the Houston Ship Channel was completed in 1914.

Houston became the magnet for all the people rushing to Texas after the victory at San Jacinto: foreign visitors, entrepreneurs, businesspeople, land speculators, gamblers, lawyers, drifters, grifters and volunteers still anxious to fight Mexicans. Add in the new Texas legislators, and you had a riotous mix. At first, Houston was a little hard to find. Francis Lubbock arrived in January 1837 on the *Laura*, the first steamship able to navigate the snag-filled Buffalo Bayou. They passed right by the Houston town site. Not too surprising since Houston at that time consisted of 12 residents and one log cabin. However, four months later, there were 1,500 people and one hundred houses.

Besides becoming the center of government and commerce, Houston also became infamous as a center for vice: drunkenness, dueling, prostitution, brawling, murder and counterfeiting—and that was just among the legislators! But the forces of civilization and law and order were not idle. The Presbyterians and Episcopalians established churches in 1839. The beginnings of a municipal police force also started in 1839 with the hiring of two constables. Gambling was outlawed in Texas in 1837, and a law punishing even the seconds in a duel was in place by 1840. Brothels were regulated to keep them distant by "two squares" from a private residence and to prevent lewd public exhibitions.

Businessmen added their voices for a more orderly city. William Marsh Rice started in business in Houston in 1838. John Hunter Herndon (also my

ancestor) arrived at Galveston on January 18, 1838, and would become the wealthiest person in Texas by 1860. Herndon kept a diary for five months after his arrival that gave one of the few accounts of early Houston.

Herndon arrived in Galveston aboard the steamship *Columbia* after a stormy three-day voyage from New Orleans. Galveston had about a dozen ships in its harbor but only six houses. He immediately embarked for Houston on a "small, filthy" steamboat, the *Sam Houston*. They had gone only seventeen miles when they grounded on Red Fish bar in Galveston Bay. It took all day to refloat, and they proceeded another seventeen miles before they stuck on Clopper's bar, which took days to get off. In that interim, Herndon and a few others took a rowboat ashore to hunt and bagged a deer, while the other passengers considered walking the rest of the way to Houston.

After a long six-day trip from Galveston, Herndon arrived to find Houston a town of small, unfinished frame houses and shanties, with dry, dusty streets, but there was a population of two thousand. Rain turned the streets into a muddy bog. Herndon observed that Houston is "the greatest sink of disipation [*sic*] and vice that modern times have known." At the Floyd Hotel, Herndon shared a room with a fellow traveler. The next day, Herndon called on President Sam Houston at his office and was greeted very cordially. The weather was very cold in January 1838, with snow and a low temperature of ten degrees; three people froze to death. On March 3, a band of Lipan Apache rode into Houston to sign a peace treaty. They looked very "intelegent [*sic*] and warlike." On March 22, "four criminals whipped at the post." On March 28, two convicted murderers were hanged with two to three thousand people in attendance.

Herndon spent much of his time courting the few single women in Houston, who seemed very proper and well chaperoned. Herndon also dreamed of kissing his cousin Willina, who was back in Kentucky. Herndon observed of Texas women, "The ladies have rather large feet, owing perhaps to their having gone barefooted a little too long."

April 14, 1838, the first day of the legislature, began with a stately address by President Sam Houston. Soon enough, a fight broke out in the statehouse, which ended when the comptroller, Lubbock, took a shot at his assailant but missed. Later, a different fight ended when one legislator killed another with a shot to the back of the head. Herndon was suggested to defend the killer at trial, but he expected him to hang nonetheless.

DAILY LIFE IN THE REPUBLIC OF TEXAS

Daily life in the Republic of Texas was a blend of gritty determination, privation, making do, inventiveness, community cohesiveness and goodwill. While the political leaders of the republic were grappling with big issues—such as admission as a state to the Union; recognition by England, France and other European countries; republic debt; paltry revenue; trade and credit; accommodation with Mexico; slavery; bad roads; Indian attacks; and setting up the institutions of a free country—ordinary citizens of the republic had their own set of challenges for survival and well-being.

There was no system of money in the republic, so most ordinary business was carried out by barter. Spanish silver coins were scarce but were the only currency honored by everyone inside the republic and by the outside world. Cotton became the item of barter with the outside markets. Imported goods, such as wheat flour, had to be paid for with silver currency or personal credit in New Orleans. The republic issued paper money in 1837, but it was quickly devalued. In 1839, two years after it was issued, republic paper bills were worth twenty-two cents on the dollar. If you could find someone to accept republic currency, you received two exchange rates (e.g., two republic dollars or twenty-five cents silver—the "two bits" of a Spanish silver dollar). A cow and a calf were considered the barter equivalent of ten dollars. If you had change coming back, you might get it in chickens or hogs. One merchant advertised the items that he would accept in barter: beeswax, honey, lard, tallow, wheat flour, bricks, planks, nails and rails. Mirabeau B. Lamar sold five hundred acres of land near Copano for a horse in 1838. People even exchanged land grant script for food. This situation persisted throughout the nine-year duration of the republic.

Since there was no money to buy necessities, Texans became very inventive and adaptable in making what they needed. Many people were dressed in homemade clothes. The men often wore pants and shirts made of buckskin. Women wore plain clothes made of calico if they could get it—if not, the cloth was homespun. The raw materials were those that were on hand: deerskins and pigskins, rawhide, wood from small trees, tallow, Spanish moss, corn husks and mortar.

Foodstuffs were equally simple. Although few people were facing starvation, their diet was unvarying. Corn was the staple food for most people. Beef was available because of the multitude of wild cattle that roamed the land, a legacy from the time of the Spanish missions. Since there was no means of

refrigeration, the beef was usually jerked or sun-dried. Domesticated cows provided milk, butter, curds and clabber. Pork was even more of a staple than beef. Wild game was very much a part of the diet, as were fish and, along the Gulf, sea birds, eggs, oysters and turtles. City dwellers found prices very high: flour for eighteen dollars a barrel, coffee and bacon for twenty-five cents a pound, sugar for twenty cents a pound, eggs at two dollars a dozen, butter for one dollar a pound, whiskey for two dollars a gallon.

In the face of the difficulties of daily life in the republic, or perhaps because of them, there was a strong spirit of community and a welcoming hospitality toward new immigrants, foreign visitors and travelers in general. William Gray from Virginia remarked that on one occasion, he arrived unannounced at the widow Anderson's house long after dark and was followed by another foot-sore traveler. Both were accommodated with supper and a bed. This was often free of charge. William Bollaert, an Englishman, and John Hunter Herndon, from Tennessee, both recorded in their journals on the hospitality with which they were received in the republic. "The habits and customs of the people at that time were few and simple. Their hospitality could scarcely be equaled."

Bollaert remarked on the Texas fellowship that regarded everyone as equal. Thus, he was surprised to see "titles, military and civil, bestowed promiscuously on all inhabitants." He was addressed as "general, major, captain, judge, doctor, and squire" at various times in his travels. Bollaert gave up on just being addressed as "mister." What life in the Republic of Texas did not afford in comfort and convenience, it paid in a sense of community and expectation of a better future. Thus was the spirit in the Republic of Texas.

FUN IN THE REPUBLIC OF TEXAS

So what did they do for fun in the Republic of Texas? Citizens were not too constrained by the laws on the books (e.g., outlawing dueling) because there was no police force to rigorously enforce the laws. So the range of options for fun was nearly unlimited. The short answer is that Texans did pretty much what they did in the southern United States for both licit and illicit entertainment.

Fancy dress balls were held to celebrate auspicious events in Texas and U.S. history. Thus, Texas Independence Day was celebrated on March 2,

the Battle of San Jacinto on April 21 and even the Fourth of July, as well as the traditional holidays of Thanksgiving and Christmas. The celebration in Houston on April 21, 1837, was especially notable for the rustic character of Houston at the time and the long distances that Texans traveled to get there. Additionally, Sam Houston had just recently returned to Houston from New Orleans, recuperated from the wound that he received at San Jacinto. President Houston was decked out in his finest livery: white ruffled shirt, scarlet waistcoat, black silk velvet suit with gold braid and black boots with silver spurs. They dined and danced until dawn.

Dancing the whole night until dawn was not that unusual in the republic since dancing was the most popular form of entertainment at all gatherings. They danced the cotillion and the Virginia reel, group dances with a caller yelling out the fancy steps—what we would probably call "square dancing" now. The music would be supplied by fiddle, base viola, fife, harmonica or whatever was available. Single ladies were in short supply and therefore at a premium. The ladies would be dressed in their best in short gowns, cut low in front with short sleeves, and with flowers or feathers in their hair.

The theater was not long in arriving in Houston and Galveston and thereafter into the hinterlands. The first theater building was opened in Houston on June 11, 1838, with a performance of a famous comedy, *The Hunchback*. On the same evening, a farce, *The Dumb Belle*, was offered. The house was standing room only. Two plays per night was the norm, and the play list was long on comedies and farces. In January 1839, a steamboat docked in Houston with a theatrical company from New York. Houston was added to the circuit for traveling stock companies from New Orleans. With local talent, theatrical productions were also held in Bastrop, Gonzales and Matagorda. A ventriloquist, E.L. Harvey, made a tour of the country theaters, with an admission price of fifty cents.

Horse racing was another form of fun that could be enjoyed by both sexes. There was a well-known race track, the New Market Course, in Velasco in Brazoria County, frequented by patrons from Houston. Houston had a Jockey Club early in the republic. The track in Velasco attracted the best horses and had the biggest purses. There were a number of racehorse breeders in Texas, including John Hunter Herndon of Brazoria. The racing season lasted only for a week. Since money was not plentiful, people could bet with livestock or even land.

Then there were the kinds of entertainment that only men would participate in: hunting, fishing, billiards, fighting, drinking, gambling, prostitution, duels and executions. These were the activities to be railed

against in the newspapers and from the pulpits, except there were no pulpits in the early republic. In hunting, wild turkeys and prairie chickens were favorite game birds. When Audubon visited Houston in 1836, he was horrified to see the hunters displaying colorful wild parrots. Visitors remarked on the high number of saloons in early Houston, at first just tents with boards on barrels for a bar. Besides the whiskey, saloons were also the sites of the card-playing gamblers. Not all immigrants came to Texas to build the republic; some were merely fugitives looking for their next quick buck. And, of course, a lot of the brawling took place in the saloons, as did the prostitution. Sometimes the fights led to a formal, illegal duel. There were public whippings for thievery and hangings for murder. On election day, rival politicians sponsored open barrels of whiskey hoping to sway the voters.

In 1839, Houston got its first start on a police force with the hiring of two constables to bring the illicit fun under more control. Merchants, churches and the newspapers also campaigned against "sin." Business and culture were on the march in the republic, and strictly male fun was under attack.

TOO MUCH SPITTING IN THE REPUBLIC OF TEXAS

Francis Sheridan remarked on the excessive amount of "spitting" by men during his stay in Galveston and Houston in 1840. Sheridan was an English diplomat who arrived in Galveston on the last Sunday in 1839 from a posting in Barbados. Sheridan kept a journal of his time in Texas and noted his disapproval of the near universal custom of spitting. He was in Texas with the mission of evaluating the desirability of England's recognition of the new Republic of Texas. England's recognition was slow in coming, as was the admission of Texas as a U.S. state.

What Sheridan meant by "spitting" was the chewing of tobacco and the subsequent liquid discharge at a spittoon, on the floor, out an open window or on the ground. Homes, businesses, public buildings and even church pews were provided with spittoons. The chewing of tobacco by men and the dipping of snuff by the gentler sex was the primary means of using tobacco in early Texas. Many had brought these practices with them from the southern states or acquired them in Texas. Most of our Texas heroes probably chewed tobacco. Such was the ubiquity of these practices that visitors rarely remarked on them.

Tobacco was native to the Americas, and Europeans were first introduced to it when Christopher Columbus encountered Indians using tobacco on the island of Hispaniola in 1492. Some Indians were smoking a primitive cigar in which tobacco leaves were rolled inside another leaf such as palm. The word "cigar" comes from a Yucatec Mayan word *sikar*, which means "to smoke." Other Indians in both North and South America were also chewing tobacco leaves. Tobacco leaves were carried back to Europe, and the use quickly caught on. By 1592, the Spanish missionaries in the Philippines were growing tobacco for the European market.

The southern United States proved to be very amenable to growing tobacco. Chewing tobacco was the most prevalent form of use in America until the advent of cigarettes in the early 1900s. Chewing tobacco comes in several forms: the loose leaves, pellets and plugs (or twists). The plug was the most widely used in early Texas. The leaf is cured, cut, fermented and pressed into shape with a binding sweetener. The plug has the advantages of compactness, portability, stability and cost. Although chewing tobacco sales peaked around 1910, it is still widely in use. Spittoons are still present on the floor of the U.S. Senate. In 1938, R.J. Reynolds still sold eighty-four brands of chewing tobacco versus twelve brands of smoking tobacco and the top-selling cigarettes, Camel.

In the 1860s, one historian noted that the chewing of tobacco was nearly universal in the South, with some form of tobacco used by the large majority of both men and women. While the men may have preferred the chewing plug, the women seem to have been more partial to the corncob pipe or dipping snuff. Despite the known health risks, the plug of chewing tobacco in the jaws of baseball players has been a common sight since 1845 and still may be seen today. Babe Ruth used chewing tobacco and died of throat cancer.

Snuff is a fine-ground, flavored, pulverized tobacco. It has traditionally been inhaled directly into the nostrils. It can be flavored or scented with fruits, flowers and spices. In Europe in the 1700s, snuff was the preferred form of tobacco use by the nobility and elite. Prominent users of snuff included Napoleon, Pope Benedict XIII and Queen Charlotte, wife of King George III. At that time, the casual connection between snuff use and nasal cancer was noted by an English doctor. However, the British House of Commons still provides members with a floral-scented snuff, "English Rose," at public expense.

Besides spitting, Sheridan also commented on the high number of bars in Houston, "The passion for erecting grog shops exceeds the thirst

for religious worship." In 1838, a visitor noted that Houston had forty-seven establishments for selling liquor, though no churches. Despite these cultural reservations, Sheridan recommended that England recognize the Republic of Texas. With his positive recommendation and that of others, the British Foreign Office signed a treaty of commerce and navigation with Texas in November 1840 and extended full recognition in 1842, regardless of the spitting.

THE INDUSTRIAL REVOLUTION CAME EARLY TO TEXAS

The earliest settlers brought little more than the clothes on their backs when they immigrated to Texas. But they came from European and American societies that were in the midst of the Industrial Revolution. The products of the Industrial Revolution that the early settlers could bring were meager—for example, an iron plow, iron hand tools, sewing needles and milled wheat flour. To start with in Texas, everything had to be done by hand, oxen or horsepower. However, the immigrants knew the mechanics and the benefits of the Industrial Revolution, and it did not take long for them to begin to implement them in frontier Texas.

The Industrial Revolution started in England in about 1700 with the steam engine, which became the major source of mechanical energy. The first steam engine was developed in the early 1700s but was used only to pump water out of deep coal mines. In 1778, James Watt made radical improvements to the steam engine and began to apply it to rotating industrial machines. The transition from wind and water energy sources to steam came to power the Industrial Revolution. Two other complementary innovations were made in the late 1700s: the power spinning of cotton and flax for thread and the introduction of coke into the process for iron smelting. In 1756, after being lost for thirteen centuries, the process for making concrete was rediscovered by a British engineer. The technologies of the Industrial Revolution spread to Europe and North America but established England's position as the major world power.

One of the first needs in frontier Texas was for gristmills to crush corn into meal and for sawmills to cut lumber. By 1826 in Texas, the first crude wooden mortar and pestles had been replaced by stone gristmills powered by horses or mules—one was even powered by a water wheel. By 1833, Stephen

F. Austin boasted of two steam-powered combination grist- and sawmills in his colony. The high-tech millstones had to be imported from England. The Industrial Revolution had come to Texas. In 1837, the Republic of Texas chartered the Texas Steam Mill Company near Houston.

Flour and grist milling were the major industries in Texas until after the Civil War. Cotton cultivation and ginning was started by Jared Ellison Groce in 1825 in the Stephen F. Austin colony. The cotton gin was invented by Eli Whitney in 1793, and the early ginning process in Texas was very labor-intensive and powered by horses. It was not until 1883 that a large steam-powered ginning plant was built by Robert S. Munger of Mexia. Sugar began to be cultivated as a commercial crop in Brazoria County in the early 1840s. A steam-powered roller mill was used to press the liquor from the sugar cane stalks, and then the stalks were burned as fuel for the steam engine or the open-kettle evaporating pans. Iron ore was mined in Texas and smelted in the first foundry in 1855.

Integral to the development of the economy in Texas was the coming of the railroad. Riverboats were better than ox carts, but development was limited to the areas accessible by water. In December 1836, the First Congress of the Republic of Texas in Columbia chartered the first railroad company. But it was not until the 1850s that the first successful rail lines were built; the first, a twenty-mile stretch from Harrisburg to Stafford, opened in 1853. By 1861, there were nine railroad companies operating over almost five hundred miles of track. High capital requirements kept the pace of railroad development in Texas to a slow pace, but the 1870s saw the addition of significant track mileage.

Although the first settlers in Texas came with little material goods or capital, they had in their heads what the Industrial Revolution could do, and they did it. Texans were not deterred by the misgivings to the Industrial Revolution that were occurring in England. The rise of capitalism in England had brought reactions in the form of Marxism and Romanticism, the latter a yearning for the way things used to be. D.H. Lawrence's *Lady Chatterly's Lover* in 1928 was an expression of Romanticism and dissatisfaction with the results of the Industrial Revolution in England.

Part V

THE STATE OF TEXAS, THE END OF THE FRONTIER

WHAT DIALECT DO YOU SPEAK?

What do you mean, "What dialect do I speak?" I speak the King's English, of course. It is all those other people who are speaking in a dialect that I can barely understand. They are the ones who need to speak better, not me. Well, sometimes I may talk a little Texan, but everybody understands me. Doncha?

Surprise! Dialects are the rule, not the exception. There are more than six thousand currently spoken languages in the world, but only about two hundred of these are also written. English counts as just one of those written and spoken languages, but it has many dialects. Standard English in England is often called the King's English or BBC English. Linguists count at least twenty-one regional dialects in England, not counting Irish and Scotch varieties. Dialects are distinguished from accents; dialects differ in vocabulary, grammar and syntax. Dialects are what we learned starting in the crib and actually speak in conversation. Standard English is what we learned in school and would be more adhered to in writing and in formal speech.

America has more than forty regional dialects, of which Texan is one. The closest thing to standard American English might be that spoken by the anchor people on network television. Texan is one of the dialects of Southern English, reflecting the origins of many southern immigrants into Texas. The southern influence can be clearly seen in the Texan use of "you all" and "y'all" for the plural of "you." Similarly, Texan has strong influences

from Mexican Spanish. Most people are unaware of their dialect since it is the language in which they are immersed.

Languages are constantly evolving, and so, too, are dialects. Texans no longer use "pulley bone"—now we call it a "wish bone." "Flapjacks" and "griddle cakes" have been replaced by "hot cakes" and "pancakes." "Red bug" is used in the coastal and southern parts of Texas, "chigger" more in the north and west. So there are regional differences even within Texas.

Texas vocabulary has some unique usages:

- "aggravated" (pronounced "agger-vated") means anything from mild annoyance to rage
- "all choked" up means to be emotional, sad, very appreciative or otherwise deeply moved
- "catty whompus" means out of line, crooked, not fitting properly, skewed
- "conniption" is being upset or angry, but less so than having a "hissy fit" or being "fit to be tied"
- "dinner" can be the noontime meal (also "lunch") or the evening meal (also "supper")
- "eating high on the hog" means dining on the choicer cuts rather than the hock or feet
- "go to the house" means to go home as from work or to go inside from outside
- "swan" used in place of "I swear," just like "dad-gumit" is used in place of cussing
- "eat up" has meanings from eaten up, corroded, rusted and depleted to sick or diseased
- "gully washer" and "frog strangler" mean a flood or excessive rain, also "turd floater"
- "fixin' to" means to be getting ready to do something or go somewhere
- "podner" means partner and can be use as a greeting to friends, like "Howdy podner"
- "sorry" is applied to persons or things that are worthless or bad, often with other expletives
- "taken to" means to start to like something or to begin doing something

Texan also has some unique pronunciations, such as "wrench" for "rinse," "in'thang" for "anything," "bald" for "boiled" and "o'vair" for "over there." Whichever dialect you speak, go ahead on. It is part of your family heritage and, therefore, your identity. You will be as distinctive as all git out.

Borders of Texas Contested for 150 Years

The borders of Texas were actively contested in the period of 1803 through 1850 and even into the 1940s. The Gulf Coast line was the least contentious border, although the precise position of this coastline arises every time a hurricane rearranges the beaches and dunes on the Gulf barrier islands. The first dispute arose in 1803 when Tejas was still a part of the Spanish colony of New Spain. President Thomas Jefferson asserted to France and Spain that Texas was included in the Louisiana Purchase, based on the explorations and settlement by La Salle. However, the Adams-Onis Treaty of 1820 established the border between Louisiana and Texas along the Sabine River. In 1941, Louisiana tried to push this border to the west bank of the Sabine River, but the U.S. Supreme Court ruled in 1973 that it remain in the middle of the river.

The southern boundary of the New Spain Department of Coahuila y Tejas was the Nueces River. In 1836, after its defeat at San Jacinto, the Mexican government tried to maintain that this was its border with Texas, not the Rio Grande. This dispute simmered until Texas was admitted to the Union in 1845, which precipitated the Mexican-American War of 1846.

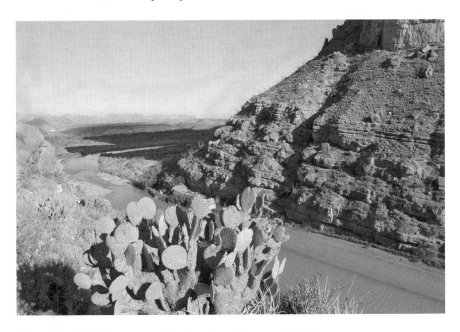

View of the Rio Grande, one of the frontiers of Texas. *David Fulmer.*

This war ended in the Treaty of Guadalupe Hidalgo in 1848 in which Mexico ceded most of its territory in the Southwest to the United States, as well as the Rio Grande River as its border with Texas. The land between the Nueces River and the Rio Grande was called the "Nueces Strip" and remained sparsely settled and largely lawless into the 1870s.

The First Congress of the Republic of Texas passed a law in December 1836 defining its borders. This resulted in the map of a huge Texas that contained about two-thirds of New Mexico, half of Colorado and parts of Wyoming, Oklahoma, Kansas and Arkansas. This was not completely fanciful on the part of the Republic of Texas since the Treaty of Guadalupe Hidalgo had explicitly noted that the western border of Texas was the Rio Grande from its mouth at the Gulf to its source. The Rio Grande is almost 1,900 miles long and flows for about 200 miles in Colorado. The federal government opposed Texas's claim to these outsized boundaries. The dispute became so heated by 1847 that some Texans threatened to secede from the Union after only two years as a state and also to seize the disputed areas by force. U.S. president Millard Fillmore took the latter threat seriously enough to reinforced U.S. Army troops in the New Mexico Territory to prevent any such action.

The problem was not just about the territory, but was very much embroiled in the issue of slavery and in money to pay the debts of the Republic of Texas. Texas's admittance as a state was opposed by politicians who did not want another "slave state" in the Union. There was even a proposal to divide Texas into three states. A contentious compromise was worked out in Congress in 1850, but it took the death of President Zachary Taylor, who was very much in opposition, to allow the measure to pass.

The Compromise of 1850 was a collection of bills that had provisions that included California, New Mexico and Utah, but most provisions were driven by the issue of slavery. Texas was recognized as a slave state and gave up all its territorial claims in exchange for $10 million from the U.S. government. Texas got the boundaries that we now have, which include all those long straight lines for Texas's northern and western borders. These boundaries were based on meridians drawn on a map. Texan voters approved the compromise territorial settlement by a vote of three to one. The Compromise of 1850 also delayed the Civil War for a decade.

THE LAST SLAVE SMUGGLED INTO TEXAS

Ned Thompson of Brazoria County was reputed to have been the last African smuggled illegally into Texas as a slave in 1840. He was interviewed by the *Brazoria Courier* in 1913. Since he was then over ninety, he must have been born in about 1820. Thompson remembered clearly the battle in which his tribe in Africa was defeated and taken captive to be sold into slavery. He could still speak his native language. He remembered the voyage to Cuba and then the clandestine trip to a landing at the mouth of the San Bernard River. After emancipation, he continued to live in Brazoria County and was shown with his wife in a 1913 photo in the newspaper.

He would have been brought in illegally in 1840 since the importation of slaves was banned in Texas, although the owning of slaves was still legal. England, the United States and many other European countries made the trade illegal in the Slave Trade Act of 1807. Slaves could be brought legally into Texas after 1807, but only from the United States. The black slaves entering Texas at this time came with their owners from the southern U.S. states, and there was initially little illegal traffic of slaves into Texas.

Jean Lafitte was responsible for a large increase in the slave trade into the United States from 1817 to 1821. From his base in Galveston, Lafitte's ships pirated in the Caribbean, and he began to capture slave ships off the West Indies. Lafitte learned that he could smuggle the slaves into Louisiana at river and bayou landings and sell to buyers in New Orleans. New Orleans was the center of the slave trade in the Deep South where young male field hands sold for about $1,000 each in the 1850s. James Bowie and his two brothers were very successful agents in the disposition of Lafitte's slave cargos. Once in Louisiana, the slaves could be sold across state lines and even legally into Texas. One lot of slaves being transported by James Bowie reportedly escaped but was recaptured by a band of Comanche. Early settlers noted the Negroid characteristics of some of the west Texas Indians they encountered. This source of slaves ended in 1821 when Lafitte was routed from his stronghold in Galveston.

Owners were allowed to enter with their slaves into the Stephen F. Austin colony in the 1820s. In 1836, at the start of the Republic of Texas, there were about 5,000 slaves in a republic population of 40,000. However, the population of black slaves increased faster than the population as a whole during the republic. In the census of 1850, slaves accounted for about 30 percent of the population of 213,000 people in Texas. The majority of this

increase came from the immigration of slaves with their owners from the southern states and only a small part from the direct illegal smuggling of slaves into Texas. One of the last attempts at smuggling occurred in 1856 at Indianola. Camels were being brought into Indianola for experimental use by the U.S. War Department as beasts of burden for troopers in the desert Southwest. One of the arriving ships with a cargo listed as camels was later found to have been carrying Africans. Ruses such as this continued up to the eve of the Civil War. So it is likely that Ned Thompson in 1840 was not the last person to be smuggled into Texas as a slave.

Although blacks accounted for the vast majority of slaves in Texas, they were not the only ones. The peonage system in Mexico amounted to virtual slavery. Some Indian tribes would sell the women and children of a defeated enemy tribe into slavery. The Pawnee Indians of north Texas were ravaged by the horse-mounted Apache, and the survivors were sold to the Spanish and Pueblo Indians in New Mexico. This trade became so established that the name "Pawnee" became synonymous with "slave"—a sad commentary of the propensity of one human group to enslave another.

THE CHIHUAHUA TRAIL STARTED IN INDIANOLA

Indianola was the most successful of the several ports founded on Matagorda Bay in the 1840s and became the eastern end of the Chihuahua Trail, which linked it to San Antonio and eventually to San Diego in California. Matagorda Bay is reached through Pass Caballo, and navigation through this pass is every bit as treacherous as that through the Aransas Pass. One of La Salle's ships foundered in Pass Caballo when he tried to enter in 1685. La Salle's colony was the start of Matagorda Bay's history. The Steven F. Austin colonists landed in 1824 at a town named Matagorda at the mouth of the Colorado River in the eastern reaches of Matagorda Bay. All of the later landings and ports were in the western end of Matagorda Bay: Dimmit's Landing, Linville, Port Lavaca and Indianola. The Matagorda Bay landings were busy during the war for Texas Independence and later during German immigration.

The growth of Indianola as a port started with the selection of Matagorda Bay as the port of entry for German immigrants in 1844. Prince Karl Solms-Braunfels made this choice, but he made almost no other preparations

when the first of thousands of German colonists began to arrive early in December 1844. They came ashore at a landing then called Indian Point. With no facilities to house or transport them, these immigrants were forced to camp on the beach for months. Into the late 1840s, the beaches of Indian Point were packed with German settlers bound for grants in central Texas. The unhealthy living conditions caused epidemics of cholera, typhoid and yellow fever. Slowly, businesses began to move to Indian Point, and in 1849, the name of the growing town was changed to Indianola.

A major impetus for growth occurred in 1850 when the U.S. Army chose Indianola as the western Gulf depot for the Quartermaster Department. Soon, massive shipments of military supplies from Baltimore and New Orleans were unloading at Indianola and heading out on the Chihuahua Trail. The camels that the army used as experimental beasts of burden also came through Indianola. Wagon trains could contain up to 150 wagons, each pulled by six mules. The Chihuahua Trail passed through San Antonio and supplied all the west Texas forts, such as Fort Stockton, Fort Davis and Fort Bliss (in El Paso). Goods bound for the silver mines in Chihuahua would enter Mexico at El Paso. Wells Fargo had a contract to move silver bullion from the mines to the U.S. Mint in New Orleans through Indianola. During the 1850s, it was not uncommon to have up to 600 wagons parked on the outskirts of Indianola waiting to pick up their cargo at the docks. There was also traffic through El Paso to San Diego for passengers who did not want to hazard a trip around the tip of South America. This volume of shipping placed Indianola second only to Galveston by the mid-1850s, and the population reached three thousand.

During the Civil War, the volume of shipping through Indianola dropped to near zero because of the Union blockade of the Confederate Texas ports. Indianola was bombarded and occupied by Union troops for about one year. After the Civil War, shipping started up again, and the railroad was extended to reach Indianola in April 1871. Indianola seemed poised to regain its prior prominence when disaster struck on September 15, 1875. A category 3 hurricane put the streets under five feet of water; 270 people died, and 75 percent of Indianola was damaged. Rebuilding efforts came to an end on August 20, 1886, when a category 4 hurricane destroyed Indianola. The post office was closed on October 4, 1887, and Indianola was no more. Indianola has little to mark its location now except for Raoul Josset's sculpture of La Salle.

THIS BOOK SAVED THE LIVES OF SETTLERS AND SOLDIERS

The Prairie Traveler, written by Randolph B. Marcy in 1859, became a bestseller for the rest of the century. It was written as a guide for the U.S. Cavalry and the cross-country settlers headed overland to California, Oregon and Utah. Marcy was a military officer, explorer, surveyor and mapmaker. *The Prairie Traveler* was authorized by the War Department and sold for one dollar; it was easy to read despite its two-hundred-page length.

Marcy was born in Massachusetts and graduated in the West Point class of 1832. He was promoted to captain in 1846 and fought in several battles with General Zachary Taylor in the Mexican-American War. Thereafter, his duty on the frontiers in Texas and Oklahoma involved exploration and mapmaking, as well as escorting immigrants. In 1852, Marcy led an expedition that explored one thousand miles of unmapped territory in Texas and Oklahoma, discovering the source of the Red River, the Palo Duro

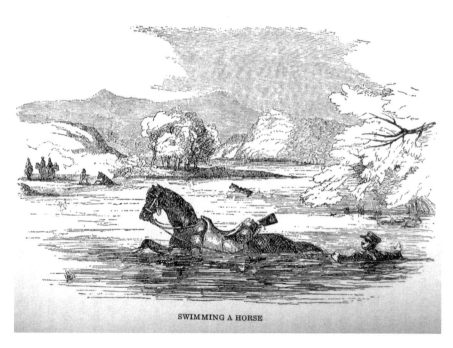

SWIMMING A HORSE

Illustration on how to cross a river with a horse from the book *The Prairie Traveler*, written by Randolph Marcy in 1859.

Canyon and a prairie dog town that extended for 400,000 acres. He distilled his decades of frontier experience into a book that was comprehensive, detailed and illustrated with original drawings.

Marcy started by describing the various routes to the West Coast. The southern route, for settlers arriving by ship at Indianola on Matagorda Bay, was best for winter travel as it was seldom closed by snow and provided green grass as forage for the animals most of the way. Marcy spent a lot of time on the animals (the oxen, horses, mules and cows) because a successful overland journey depended on their endurance and health. He said that a wagon with a six-mule team should only be loaded with two thousand pounds if grass was the only forage. Generally, only a small amount of emergency feed grain could be carried.

Marcy discussed the pros and cons of oxen versus mules as beasts of burden. Oxen had a number of advantages for the two-thousand-mile trip to the West Coast. One was that oxen were less excitable and less likely to be stampeded and stolen by Indians. A single ox-pulled wooden cart could convey one thousand pounds, so oxen were very cost effective, slow but steady. Mules were better than horses. A quirk of mule behavior is that sometimes in crossing a river, they would become so terrified that they would simply lie down and not move. They would then have to be dragged across with a rope. Marcy wrote, "I have even known some mules refuse to put forth the least effort to get up after being pulled out upon firm ground, and it was necessary to set them upon their feet before they were restored to a consciousness of their own powers." But mules were superior to horses and dogs as sentinels. "Mules are keenly sensitive to danger, and…they will often detect the proximity of strangers long before they are discovered by their riders."

Marcy recommended a daily ration for walking men of two and a half pounds of food, mainly consisting of pemmican and biscuits. The recipe for pemmican was to cut up and dry buffalo meat, then pound it into a powder and place it in an animal skin with the hair on the outside. Next, pour in melted grease and then sew up the skin. Marcy described pemmican as "wholesome and nutritious" and noted that it "will keep fresh for a long time." He did not say anything about taste.

Marcy thought that wool was the best material for clothing and described how to sew various garments. Leather boots with wool socks were replaced by moccasins for travel in deep snow, and wool pants were replaced by elk skin. An awl and buckskin strips were absolutely necessary for clothing fabrication and repair on the trail. Marcy also estimated the time it would

take a wagon to travel from the Missouri River to California at 110 days. He then detailed how to travel, set up a secure camp, cross a river, find water, avoid a stampede and so on. He even recommended substitutes for exhausted supplies, such as red willow bark or sumac leaves for tobacco, dried wild horse mint for coffee and a sprinkling of gunpowder for salt and pepper. Marcy's book was indispensable reading for any settler venturing by wagon train to the West Coast, as well as any military expedition dealing with the Indians. It saved lives.

TOBACCO CROSSED THE ATLANTIC THREE TIMES

Tobacco crisscrossed the Atlantic at least three times, from its discovery by Christopher Columbus in 1492 to its importation into Europe in the early 1600s as an export product of the American colonies, with its worldwide use increasing exponentially on each passage. Tobacco plants were native to the New World, probably first found in the jungles of Cuba, and its narcotic and medicinal use were recognized prehistorically. From its early and widespread use in the Americas, tobacco has found its way into current use by about one-third of the world's adult population, despite its now-recognized harmful health effects.

All twelve species of tobacco are native to the New World. Three species of tobacco grew wild in Texas. The diffusion of tobacco culture from South America and its various uses by Native Americans were well established by the time of European contact. The distribution of tobacco in the Americas was largely coincident with that of maize (corn) agriculture from Chile to Canada. Columbus noted the intoxicating and addicting effects of smoking tobacco in Cuba in 1492. Besides being smoked, tobacco leaves were also chewed and used in the form of snuff. The first pictorial record of smoking was found on a pottery vessel in Guatemala dated AD 600–1000 that showed a Maya smoking a roll of tobacco leaves. The name comes from *tabacco*, the Spanish name for the plant. New World tobacco was taken to Spain in quantity in 1518 and the tobacco plant in 1558. Thereafter, the worldwide use of tobacco spread rapidly with the European explorers. Tobacco was introduced into England by Sir Walter Raleigh in 1584.

Tobacco agriculture recrossed the Atlantic from Europe to America with the European colonizers. The immigrants were already using tobacco as a recreational drug and medicine, but it quickly became a commodity

crop and a major trade item. John Rolfe was the first early English settler to successfully cultivate tobacco in Jamestown in 1609. Rolfe was also the Englishman who married Pocahontas. Rolfe had secretly obtained seeds for tobacco then being grown in Trinidad, while Spain was trying to maintain a monopoly on tobacco production. By 1620, forty thousand pounds of tobacco were exported annually to England from the Virginia Colony. That was tobacco's third crossing of the Atlantic.

The Indians in Texas gathered and cured wild tobacco and even grew small plots. Tobacco was also grown in colonial Mexico, and tobacco, along with chocolate, was sent to the Franciscan mission at Refugio in Texas in 1800. When John Linn arrived at the future site of Corpus Christi in August 1829, he arrived with a load of contraband tobacco leaves. He loaded the tobacco bales onto mules and carried them down to Mexico for sale along the border. James Power imported tobacco for his store in Aransas City in the 1840s. Power did a brisk trade in tobacco and may have used his warehouse in El Copano for storage. After Power and his store were surrounded in 1838 by Mexican brigands, young Walter Lambert eased the standoff with a ransom of twenty-two bales of tobacco. In frontier Texas, similar confrontations with Indians had been averted by gifts of tobacco to assuage anger.

Pioneer settlers in Texas grew several species of Kentucky and Tennessee tobacco on their farms for home consumption, with excess product showing up at local markets. The first cigar manufacturing in Texas was done before 1836 by Freidrich Ernst, who sold his tobacco products in Austin's colony at San Felipe. The first tobacco grown for the market in Refugio County was started in 1856 by Anton Strauch, who grew tobacco on his farm on Salt Creek, dried it and processed it into cigars. It is estimated that Texas produced about seventy thousand pounds of tobacco in 1850 in small-scale operations. So what began as a prehistoric, small-scale American Indian practice became a nearly universal habit and was then traded and gifted back to Indians in Texas in the 1850s.

THE CEMETERY: LAST RELIC OF ST. MARY'S OF ARANSAS

The Cemetery of St. Mary's of Aransas is the only visible remnant of that once thriving town on Copano Bay. The cemetery was founded in 1857, the same year as the town of St. Mary's, when Joseph Smith donated ten

acres of land just outside the town. The date of 1860 is on the earliest headstone in the cemetery. The Wood Mansion is the only other structure from this period, but it was built in 1875 and at the time it was in Black Point, just outside St. Mary's. All of the other houses and businesses in St. Mary's were either destroyed in the hurricanes of 1875, 1886 and 1887 or were disassembled and moved to nearby towns and reused for their precious lumber.

The St. Mary's cemetery is the resting place for some of the early pioneer families of St. Mary's, as well as the founding families of Bayside. The earliest headstone in the cemetery belongs to Callie Grover Stribling. She was the wife of Cornelius K. Stribling and died in 1860 at the age of twenty-three. Cornelius Stribling was one of the first attorneys in St. Mary's, and the Stribling family had been in Refugio County since the 1840s. Callie Stribling's headstone is at the far west end of the cemetery, an area that seems to contain the oldest graves. Most of this area is bare of headstones, so it is possible that other early residents were interred without markers.

General Thomas T. Williamson was one of the founders of the town of St. Mary's, along with Joseph Smith. The wife of Williamson, Tirzah Ann McWillie Williamson, is buried in the cemetery, although there is no headstone for him there. Tirzah Ann was the owner of record for eighty land certificates (totaling 51,200 acres) issued by the Republic of Texas. She formed a partnership with Joseph Smith in 1838 on the basis of these land certificates. The certificates were exercised on land that had been granted earlier to the empresario James Power. A decade-long battle through the Texas courts resulted in a title judgment against Power in 1856, and Smith immediately went to work promoting St. Mary's of Aransas. Tirzah died in St. Mary's in December 1869 at the age of sixty-seven.

The headstones at St. Mary's cemetery also testify to the hazards of life in Refugio County in this early period. There are a number of small markers for unnamed infants. Other headstones point to death in childbirth and in epidemics. Callie Grover Stribling was still newly married when she moved from Victoria to St. Mary's and soon died of a fever. Still others were involved in violent deaths. John Maton had a butcher shop in St. Mary's. He was only thirty-five years old when, on May 14, 1877, he was killed in an ambush along with John Welder. Andrew J. Martin was a constable in Refugio County. In 1879, Martin and Tom Pathoff were in a skiff on the Mission River when a man named McCane pointed a shotgun at them. Pathoff saved himself by jumping into the river, but Martin was killed. McCane received a life sentence for the killing.

The "old" St. Mary's cemetery was shown in a plan of the new Bayside cemetery in 1914 as an unplatted block surrounded by 120 new grave plots. The plan also shows a chapel in the center, but there is no evidence that the chapel was ever built. The cemetery is still in active use today by the residents of Bayside. It provides tranquil, shady grounds as a final resting place near Copano Bay.

The Devil's Rope Marked the End of the Texas Frontier

Barbed wire was the "devil's rope," and its introduction into Texas in the 1870s changed the face of the land and marked the end of the Texas frontier. Barbed wire was part of a larger advancement of the Industrial Revolution into Texas and arrived at about the same time as the railroads and with the wider use of windmills on ranches and farms. One of the effects of these developments was to eliminate the need for long cattle drives to a distant railhead, like Abilene, Kansas. The open range in Texas disappeared, replaced by large fenced ranches, smaller farms and new towns.

Barbed wire was essentially an American invention, although the original idea came from France in 1860. The idea was picked up in New York, and American inventors began to work on a practical design for animal containment. In 1867, six patents were issued for barbed wire. Joseph Glidden was a farmer in 1867 when he saw a demonstration at the De Kalb County Fair involving barbed wooden blocks hanging on a smooth wire fence. In 1874, Glidden patented the design of two twisted, smooth wires holding sharp wire barbs at spaced intervals. More patents followed, but Glidden's basic design won out. Eventually, there would be more than 530 patented barbed wire designs, with more than two thousand variations of barbs. Between 1873 and 1899, there were as many as 150 U.S. factories making barbed wire to supply the demand in the West.

Barbed wire came to Texas in 1876 at a famous demonstration in Alamo Plaza in San Antonio. Glidden's barbed wire fence was able to contain a herd of longhorn cattle. "Light as air, stronger than whiskey, cheap as dirt" was the pitch. The demand in Texas came from ranchers who needed to control their vast acreage, farmers who wanted to keep cattle out of their

Joseph Glidden's patented design of barbed wire. *Sebastian Peleato.*

crops, cattle raisers who wanted to keep sheep out of their pastures and railroads that needed to keep cattle out of their right-of-way.

By 1880, all the public land in Texas had been claimed, and a barbed wire fence became the way to enforce a claim. In the frenzy to fence land in the early 1880s, public land and roads were fenced, as were other people's farms. In January 1884, the Texas legislature made it a crime to fence public land and right-of-way or others' property, as well as making it a felony to cut a legal fence.

The use of fencing restricted access to the traditional sources of open-range surface water: streams, springs, rivers and lakes. Now each farm and pasture needed its own source of water. Also, the railroads needed water at each stop for the engines and the passengers. This led to the increased use of wells and windmills to tap into ground water. The American version of the windmill was invented in 1854 by Daniel Halliday in Connecticut. It was fairly simple and cheap and could be handmade. The introduction of the windmill opened up land for development where there had been no sources of surface water. In 1860, the Houston Tap and Brazoria Railway began to build windmills along their right-of-way from Houston to Wharton.

Windmills also came to the cattle ranches in the 1870s and provided the means to improve the breed of cattle and the quality of beef. Prior to that,

Texas windmill at sunset near Bayside. *Linda Brinkley.*

the only breed of cattle was the longhorn, which was hardy enough to make the long trail drives. But its meat was tough and fibrous. Newton Gullet and James McFadden were among the first ranchers in the Coastal Bend to start using barbed wire to fence pastures. By 1879, fenced pastures were being used to segregate cattle and allow selected longhorn heifers to be crossbred with Brahma bulls. Other ranchers started to introduce new breeds into

the mix: Angus, Durham, Holstein and Jersey. This crossbreeding required separate pastures with their own source of water. By then, the railroads were coming to the cattle, so an improved quality of beef became available for the mass markets.

This synergism of barbed wire, windmills and railroads essentially marked the end of the frontier in Texas, eliminating the free range that had been populated by bison, Indians, early settlers, cowboys and mustangs.

INDEX

INDEX

V

W

ABOUT THE AUTHOR

H erndon Williams lives in Bayside, Texas, on the site of the abandoned town of St. Mary's of Aransas. He is a native Texan, born and raised in Houston. In the course of his historical research, Dr. Williams found that his three names (Calvit, Herndon and Williams) all came from pioneer ancestors who played significant roles in Texas in the frontier period from 1822 to 1860. After a career as an environmental chemist, Williams retired to Bayside and began to develop his interests by writing a historical-interest column for local newspapers. He is a member of the Refugio County Historical Commission and the Bayside Historical Society and is the editor of its quarterly publication, the *Baysider*. His first book, *Texas Gulf Coast Stories*, was published in 2010 and is available from The History Press and national book sellers. He can be reached at PO Box 55, Bayside, Texas, 78340.